IMAGES
of America

WALLA WALLA

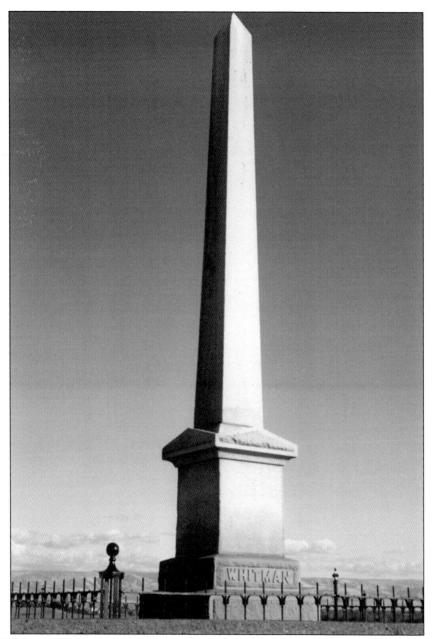

The Whitman National Monument was formally established in 1940 to remember missionary Marcus Whitman. He and his family were the first people of European descent to arrive in the Walla Walla Valley when Whitman established a mission a few miles west of modern-day Walla Walla in 1836. There he ministered to the Cayuse Indians. He built a farmhouse, a sawmill, a gristmill, and an irrigation system, and he planted an orchard. But it was only a matter of time before the Indians grew restless. When a measles epidemic reached the remote mission, Whitman's medicines worked for his family and friends but had little effect on Indians with the disease. His inability to cure them was due to their lack of natural immunity, but they didn't understand that. They thought the doctor was poisoning them. On November 29, 1847, the Cayuse launched an attack on the mission, killing most of its inhabitants.

IMAGES
of America

WALLA WALLA

Elizabeth Gibson

ARCADIA
PUBLISHING

Published by Arcadia Publishing
Charleston, South Carolina

Printed in the United States of America

Library of Congress Catalog Card Number: 200410159

For all general information contact Arcadia Publishing at:
Telephone 843-853-2070
Fax 843-853-0044
E-mail sales@arcadiapublishing.com
For customer service and orders:
Toll-Free 1-888-313-2665

Visit us on the Internet at www.arcadiapublishing.com

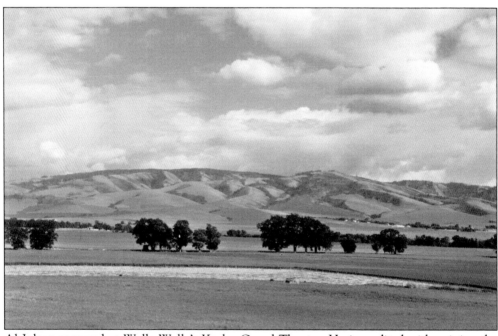

Al Jolson appeared at Walla Walla's Keylor Grand Theater. He is credited with coining the phrase "Walla Walla—the town they liked so well, they named it twice." Though Walla Walla is actually an Indian expression meaning "many waters," Walla Walla is so nice that many families have lived in the area for several generations. Looking at this photo of the Blue Mountains, it is easy to see there is a lot to like.

CONTENTS

ACKNOWLEDGMENTS

The following organizations and individuals provided images for this book. For reference, the letter "a" refers to the image on the top of the page and the letter "b" refers to the image on the bottom of the page.

Fort Walla Walla Museum: 10b, 11a, 11b, 13b, 15a, 16b, 18a, 18b, 19a, 19b, 31, 34a, 38a, 40a, 41a, 43a, 43b, 47a, 47b, 51b, 52, 56, 57a, 57b, 58b, 59b, 62a, 63 64b, 65a, 65b, 66, 67a, 68a, 72a, 72b, 74a, 74b, 75a, 76b, 77a, 77b, 81b, 93, 100a, 100b

Elizabeth Gibson: 2, 4, 12, 13a, 17, 20, 26b, 27, 34b, 35a, 37a, 38b, 39b, 41a, 42a, 44a, 44b, 45a, 45b, 48a, 48b, 50a, 50b, 53, 54a, 55, 58a, 59a, 59b, 60a, 60b, 61a, 70, 73, 75b, 78a, 78b, 80a, 80b, 81a, 82, 83a, 94, 96b, 98a, 99, 101, 111a, 111b, 112a, 114b, 115a, 116b, 117a, 119b, 120, 121, 124a, 124b, 127a, 127b, 128a, 128b

Allen Hoffman: 110a, 110b

Wes and Shirley Miller: 37a, 37b

Penrose Memorial Library, Whitman College: 9, 10a, 14a, 14b, 15b, 16a, 21, 22a, 22b, 23a, 23b, 24, 25, 26a, 28a, 28b, 29, 30a, 30b, 32a, 32b, 33a, 33b, 35b, 36a, 36b, 37b, 39a, 40b, 41b, 42b, 49a, 49b, 51a, 53b, 54b, 59a, 60a, 61b, 62b, 63, 64a, 67b, 69, 71a, 71b, 72a, 72b, 76a, 79a, 79b, 90, 97, 98b, 99a, 99b, 106a, 106b, 107a, 107b, 108a, 108b

Pook Smith: 46

Walla Walla Community College: 91a, 91b, 92a, 92b, 93a, 93b, 95a, 95b, 96a, 120a, 125a, 125b, 126a, 126b

Walla Walla Downtown Association: 117b, 118a, 118b, 119a, 119b

Walla Walla Fair & Frontier Days: 102a, 102b, 103a, 103b, 104a, 104b, 105a, 105b, 106a, 123

Walla Walla High School: 83b, 84a, 84b, 85a, 85b, 86a, 86b, 87a, 87b, 88a, 88b, 89a, 89b, 90

Walla Walla Sweet Onion Marketing Committee: 113b, 114a, 114b, 115a, 115b, 116a, 116b

U.S. Army Corps of Engineers, Walla Walla District: 109a, 109b, 110a, 112a, 112b, 113a

The Yenny family: 68b

Winsoms of Walla Walla: 122a, 122b

INTRODUCTION

The first inhabitants of Walla Walla County were the Cayuse, Umatilla, Walla Walla, and Nez Perce Indians. They lived from the foothills of the Blue Mountains to the confluence of the Walla Walla River with the Columbia River to the west. After Lewis and Clark paved the way, fur traders came to Walla Walla country to trade beaver skins with the local tribes. The first trading fort was built on the Columbia River near the mouth of the Walla Walla River in 1818.

In the 1830s, missionaries came to the Pacific Northwest from the East Coast. Dr. Marcus Whitman brought his family to teach the Native Americans in the area, and he established a mission near present-day Walla Walla. On November 29, 1847, one of the most famous events in Western history occurred: the Whitman Massacre. Cayuse Indians attacked the mission when Whitman's medicine failed to cure tribe members suffering from measles. The massacre sparked a war that lasted several years.

Once treaties were signed with the Indians in the 1850s, more settlers came to the area. The army built a military fort, and cattlemen were attracted to the area because of the abundant bunch grass and a good water supply. A county government was established in 1859, and the city of Walla Walla was incorporated in 1862. The soldiers moved the fort one more time to the present-day location of Walla Walla.

Walla Walla boomed in the 1860s as miners going to the gold fields in western Idaho came through town to stock up on supplies. Other entrepreneurs took advantage of all the traffic and planted orchards, sowed grain, and opened all kinds of businesses from dry goods stores to saloons. Flour mills and saw mills were the first and most prosperous businesses. These were followed rapidly by schools, churches, banks, and city government offices. The first newspaper in the state was established in Walla Walla during this time. And it had much to report, since the city had—like many other Wild West towns—its share of gunslingers and vigilantes.

Eventually the boom would go bust, and suddenly the city had a surplus of agricultural goods. Walla Walla was far from any metropolitan area or train station. Several stage lines served the town, but the stages could not haul crops. Dr. Dorsey Syng Baker envisioned building a railroad from the fledgling community to the mouth of the Walla Walla River where it spilled into the Columbia. His unconventional railroad brought a renewed prosperity to the city. The city was connected by telegraph in 1875 and received regular mail service by 1879.

At this point, Washington was still a territory. The first constitutional convention was held at Walla Walla in 1878 to decide issues of statehood. Washington did not become a state until 1889, and Walla Walla lost its bid for the capital, even though it once had been the largest city in the state. Olympia became the capital, Yakima won the state fair, and Walla Walla received the state penitentiary. A temporary territorial prison had operated in Steilacoom in Puget Sound since 1887; in 1889 the permanent state penitentiary opened in Walla Walla.

During this time, the Whitman Seminary opened for its first college students. This school would later form the basis of Whitman College, a liberal arts school operated by

Congregationalists. Walla Walla College, located in a bedroom community known as College Place, was established by the Seventh Day Adventist Church in 1892. These two four-year colleges form the backbone of an education-oriented community today.

Walla Walla's agricultural pre-eminence continued to grow throughout the turn of the century. Grain production kept several mills busy. Apples were the most popular orchard fruit and they did very well in the warm summer climate. Peaches and apricots were also planted. Row crops such as potatoes, onions, and squash grew well in the rich soil. Walla Walla became known as the Garden City. With all the farming going on, many related businesses arrived to support it, such as those that sold horses and mules as well as plows and harvesters. A large proportion of the vegetable growers were Italian, with a smaller group of Chinese descent. One of the most famous growers was Peter Pieri of Corsica. He was responsible for bringing the onion seeds that, after cross-breeding, produced the famous Walla Walla Sweet Onions. Not only did these onions have excellent flavor, but it was possible to plant the bulbs in the fall for a mid-summer harvest, much earlier than other varieties that had to be planted in the spring. The variety is patented and can only be grown in certain counties in Washington.

World Wars I and II changed the complexion of Walla Walla. High demand for grain and beef to feed the soldiers overseas boosted the economy. Canning for long-term storage also became more important to the economy, with such diverse crops as asparagus, peas, and spinach. The old fort, decommissioned in 1915, temporarily became a training camp for the country's infantry. The airport was used to train bomber pilots. After the end of World War I, a veterans' hospital took over the old fort grounds.

After the World War II, the U.S. Army Corps of Engineer established a new district of Walla Walla. The Walla Walla district was the headquarters for corps operations in Washington, Oregon, Idaho, Wyoming, and small portions of Utah and Nevada. Hydroelectric dams on the Columbia and Snake Rivers were a major portion of their work. So were major fish hatcheries in the Pacific Northwest. Locally, the corps built the Mill Creek Dam and Reservoir, ending the seasonal flooding problems in the valley.

Growth in the area continued, though the hard winter of 1955 wiped out much of the valley's orchard, an event from which the area has never recovered. A large shopping center opened in 1960. A new community college was founded in 1967. A new public library opened in 1970. And the Blue Mountain Mall opened its doors in 1988.

In some ways, the city doesn't look much different from its beginnings. The military still has a presence in town with the U.S. Army Corps of Engineers, the veterans' hospital, and Fort Walla Walla. The state prison employs a large percentage of the population, just as it did at the turn of the century. Agriculture, especially onions, wine grapes, and grains, are also a large source of income. The Boise Cascade Paper and Pulp Mill also provides a living for many city and county residents. The area's two four-year colleges and junior college provide area residents with advanced learning opportunities as well as employment for graduates and teachers. With its recently restored downtown area and numerous awards the city received for its preservation efforts, Walla Walla stands to be a city for the future.

One

FORT WALLA WALLA DAYS

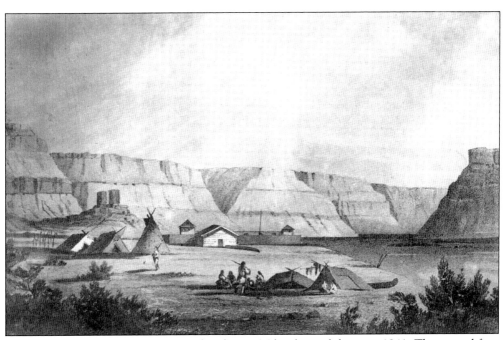

The first Fort Walla Walla was completed in 1836 but burned down in 1841. The second fort, pictured here, was built of adobe in 1842. The fort was situated near modern-day Wallula on the Columbia River and faced southwest toward the basalt rock cliffs today known as Wallula Gap. The fort was abandoned in 1855 because of "Indian problems," and later became the site of the town of Wallula.

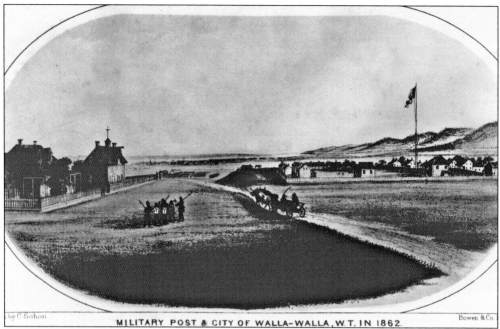

MILITARY POST & CITY OF WALLA-WALLA, W.T. IN 1862.

Fort Walla Walla existed in three different locations in Walla Walla City. This picture shows the second location, at approximately Main and First Streets, where the Book and Game Company is now located. This is artist Sohon's rendition of the fort and city as it appeared in 1862. A portable saw mill was erected and logs from the Blue Mountains were cut to build the fort's various buildings.

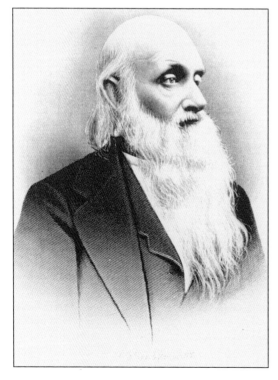

Dorsey Syng Baker came to Walla Walla in 1859, opened a store, and became wealthy during the gold rush years of the 1860s. He donated property for the first school at Cherry, Palouse, Sumach, and Spokane Streets, and he built the first railroad from the Columbia River to Walla Walla, a distance of about 30 miles. Baker died in 1888, having left a lasting mark on the city.

This picture of Burwell W. and Mary Bussell and their son Leland was taken by B.B. Day in September 1869, when Leland was six months old. This early Walla Walla family lived in a house that Bussell built himself.

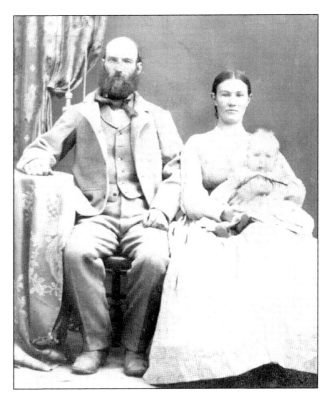

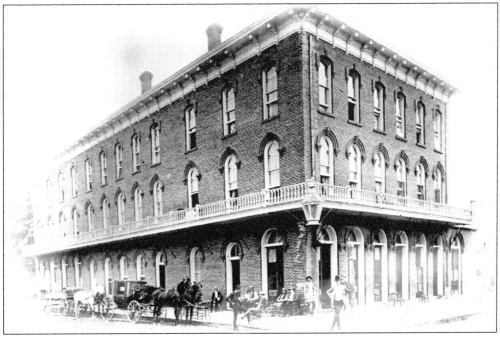

With 50 rooms, Hotel Stine was the largest brick hotel in Washington territory when it was completed in 1873. Built by blacksmith Fred Stine, who came to Walla Walla in 1862, the hotel served as the stage depot and meeting place in the early days. It was located at Fourth Avenue and Main Street until it burned down on July 22, 1892.

UNITED STATES OF AMERICA.

Territory of Washington, County of Walla Walla.

In the District Court of the United States, First Judicial District.

I _T. L. Wickens,_a native of _England_
do declare on oath, that it is bona fide my intention to become a citizen of the United States of America, and to renounce all allegiance and fidelity to all and any foreign Prince, Potentate, State or Sovereignty whatever, and particularly to _Victoria Queen of Great Britain & Ireland._ And that I will support the Constitution of the United States of America, so help me God. _T. L. Wickens_

Subscribed and sworn to, before me, at my office, this _24th_ day of _June_ A. D. 1878. _A. Kees Ayres_

Clerk of U. S. District Court for said County.

by L. B. Thompson Deputy

TERRITORY OF WASHINGTON, }
County of Walla Walla. } ss.

I _A. Kees Ayres_ Clerk of the District Court of the United States, within and for said County, in the Territory aforesaid, do hereby certify that the above is a true copy of the original declaration of intention of _T. L. Wickens_ remaining now on file in my office.

IN TESTIMONY WHEREOF, I have hereunto subscribed my name, and affixed the Seal of said Court, at my office, this _24_ day of _June_ A. D. 1878.

A. Kees Ayres

Many of those who came to Walla Walla in the early days hailed from foreign countries. T.L. Wickens, from England, came to Walla Walla and became a United States citizen. This citizenship paper was executed and signed in Walla Walla in June 1878. The paper declares that Wickens had renounced his loyalty to any other country, particularly to Queen Victoria of Great Britain and Ireland, and that he now supported the Constitution of the United States.

12

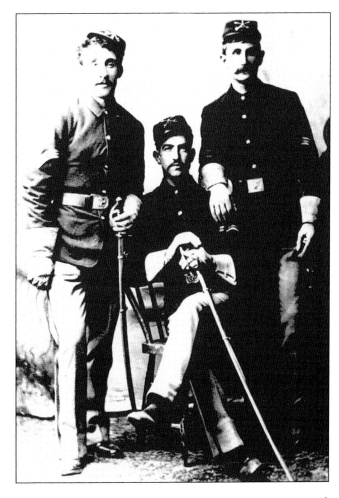

Walla Walla was served by the famous Walla Walla & Columbia River Railroad, built by Dorsey Syng Baker. It was popularly called the Rawhide Railroad, though the rails were not constructed of rawhide but of wooden rails topped with strap iron. This is a receipt for money received from the Oregon Steam Navigation Co. by the Walla Walla & Columbia River Railroad in 1880.

Pictured here, c. 1884, is Charles Stillinger, from Company H of the 1st Regimental Cavalry, which existed from 1873 to 1884. During this time, troops from Fort Walla Walla fought in the Modoc Indian War in southern Oregon.

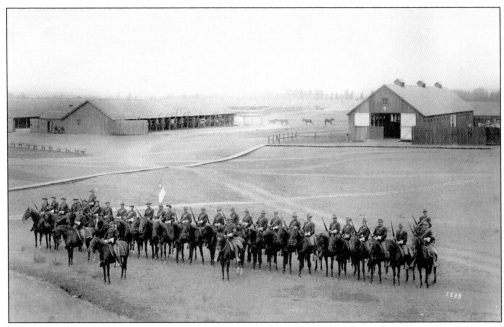

When this 1886 picture of Fort Walla Walla was taken, the fort was located in its final home off today's Myra Road. This view shows the 2nd Regimental Cavalry on maneuvers.

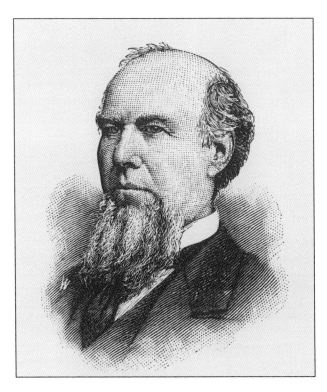

Henry P. Isaacs, one of the earliest residents of Walla Walla, arrived in 1862 and established the North Pacific Flour Mill, which was located where Wildwood Park is today. Isaacs planted one of the first orchards in the area and also served in the territorial legislature. One of the major streets in Walla Walla is named after him.

Many of the immigrants that came to the Walla Walla valley were of Scottish descent, and Jane Bane McBrae was one of them. Born in Scotland in 1805, she came to Walla Walla after first living in Illinois. McBrae lived the rest of her life here and died on April 19, 1889.

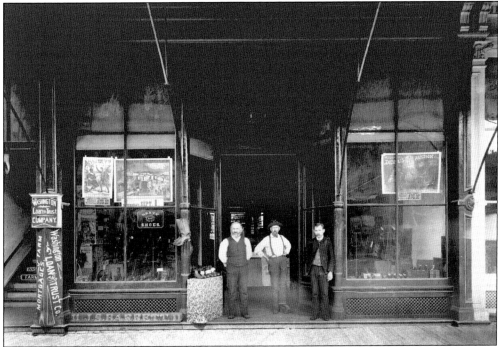

James S. Barrett is pictured on the left in front of the Barrett Shoe Store at 11 East Main Street about 1890. Parker Barrett began operating the store around 1911 and did so until 1965. There is no longer a shoe store in this location, but the building still stands on Main Street.

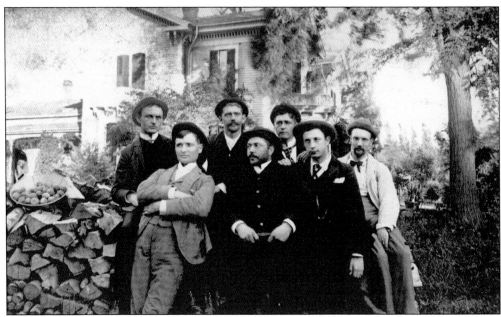

Pictured here in 1890, from left to right, are several important men from the town's early days: T.C. Elliot, Park Weed Willis, G.P. Anderson, Harry Reynolds, Allen H. Reynolds, William Kirkman, and Rev. E.R. Loomis. Allen H. Reynolds was the president of the Whitman College Board of Trustees, and William Kirkman was an important cattleman and businessman, whose home still stands on Colville Street.

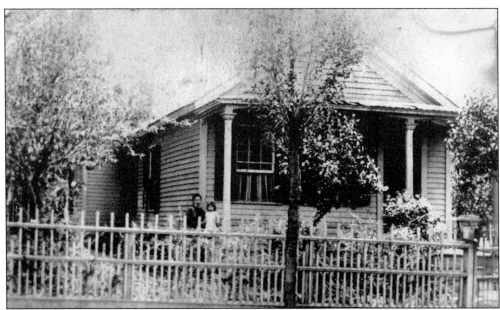

Charlotte Baumeister (Thompson) and her mother, Alvina, are pictured in front of the family home on Alder Street, c. 1881. Max Baumeister came to Walla Walla in 1862 and established the Oriental Baths. He also ran a successful insurance and real estate business. Today his office building still stands and a street is named after him.

HOLLAND GIN

STEWART & HOLMES DRUG CO.

DISPENSING PHARMACISTS,
WALLA WALLA, WASHINGTON.

LIME WATER

*Useful in allaying Sick Stomach, and in Dyspepsia
attended with acidity of the Stomach.*
*Dose: For adults 1 tablespoonful; children from 1 to 2 teaspoonfuls in a
little milk. For sick stomach repeat after each effort to vomit.*

STEWART & HOLMES DRUG CO.

DISPENSING PHARMACISTS,
WALLA WALLA, WASHINGTON

SYRUP RHUBARB

DOSE.—As a laxative, to a child one year old, one
teaspoonful.

STEWART & HOLMES DRUG CO.

DISPENSING PHARMACISTS,
WALLA WALLA, WASHINGTON.

TINCT. OF ARNICA

STEWART & HOLMES DRUG CO.
DISPENSING PHARMACISTS,
WALLA WALLA, WASHINGTON

BLACKBERRY BRANDY

STEWART & HOLMES DRUG CO.
DISPENSING PHARMACISTS,
WALLA WALLA, WASHINGTON.

☠ **POISON** ☠

STEWART & HOLMES DRUG CO.
DISPENSING PHARMACISTS,
WALLA WALLA, WASHINGTON

ROSE WATER

STEWART & HOLMES DRUG CO.
DISPENSING PHARMACISTS,
WALLA WALLA, WASHINGTON.

MURIATIC ACID.
☠ **POISON** ☠

ANTIDOTE: Give no Emetic; Give at once large draughts of
water or milk with chalk, Magnesia or Baking soda, then
white of eggs, beaten up with water or give olive oil.

STEWART & HOLMES DRUG CO.
DISPENSING PHARMACISTS,
WALLA WALLA, WASHINGTON.

CASTOR OIL

STEWART & HOLMES DRUG CO.
DISPENSING PHARMACISTS,
WALLA WALLA, WASHINGTON.

The Stewart & Holmes Drug Company was one of the earliest businesses in Walla Walla. H.E. Holmes opened a retail drug store in 1873 and merged with A.B. and A.M. Stewart in 1888. These old bottle labels, dating from the 1890s, show the wide variety of products sold at the drug store. The store was sold to Green and Jackson Drug when A.M. Stewart died in 1896. Green and Jackson is still in business today at 19 West Main Street.

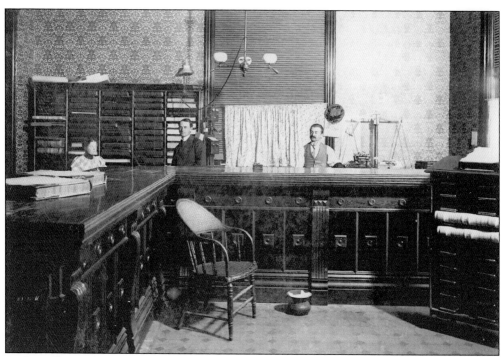

Auditor Elmer McGuire stands in the center of the city auditor's office, amidst his deputies, in this *c.* 1895 image.

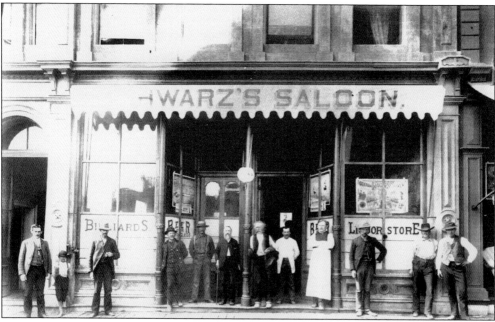

Pictured in front of Schwartz's Saloon, at 120 Main Street between Third and Fourth Avenues, is owner Adolph Schwartz, the man wearing the apron. About 1910, the establishment's name was changed to Fountain Saloon. During the era of Prohibition, however, the business was called The Fountain and sold only soft drinks and cigars. About 1922, it became a billiard hall. The business changed hands and names twice more before finally closing in 1959.

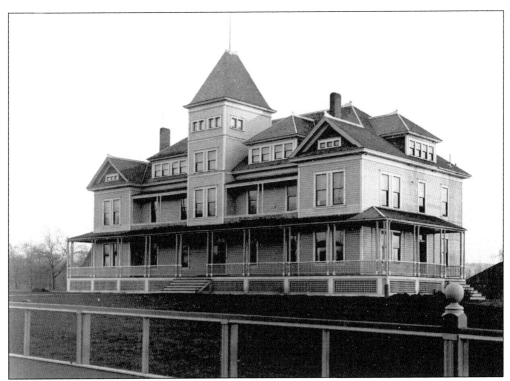

The International Order of Odd Fellows (IOOF) organized their first lodge in Walla Walla on February 23, 1863 and, in 1897, erected the Odd Fellows Home for the Aged on Boyer Avenue. The contractor for the project was a local man named N.F. Butler. The structure was built on an exceptional location since Mill Creek ran through the property and could furnish irrigation water. J.M. Swan was the first superintendent of the home.

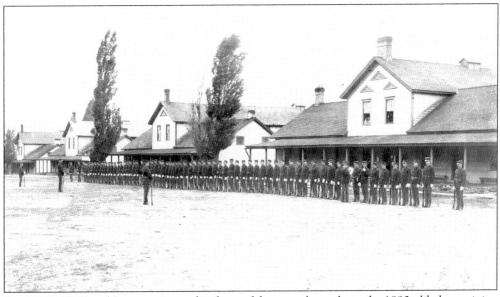

Fort Walla Walla soldiers are pictured in front of the troop barracks in the 1890s, likely receiving a morning inspection or orders for maneuvers.

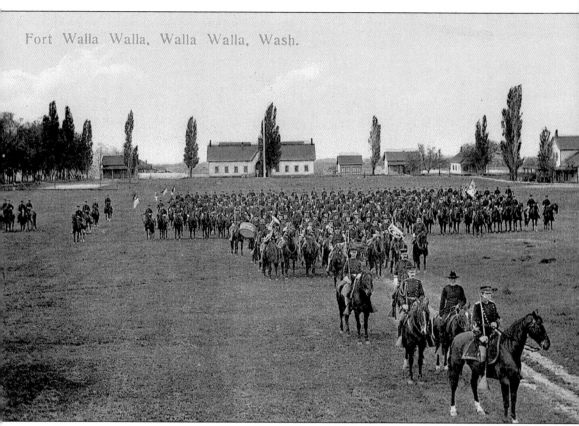

This picture of troops on maneuvers at Fort Walla was taken about the turn of the 20th century. The fort would not survive much longer; it was decommissioned as a military fort in 1910 and used only briefly during World War I.

Two

WASHINGTON STATE PENITENTIARY

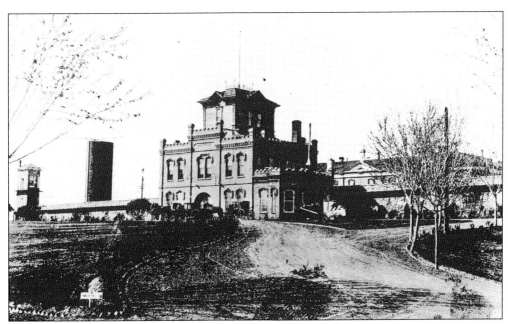

Walla Walla was selected as the site of the first territorial prison in 1886. The first prisoners arrived from a temporary site near Tacoma in May 1887. This administrative building, completed in 1907, was built using inmate labor. Afterward, the female prisoners that had been kept in the old administrative building were moved to the hospital building.

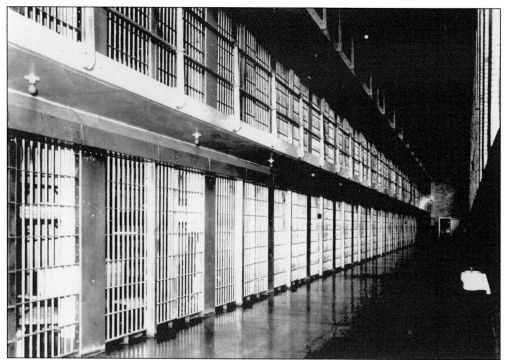

This c. 1920 photo shows a typical cell block. This cell block is part of the original penitentiary and part of today's maximum security area contained within the mortared-stone maximum security wall.

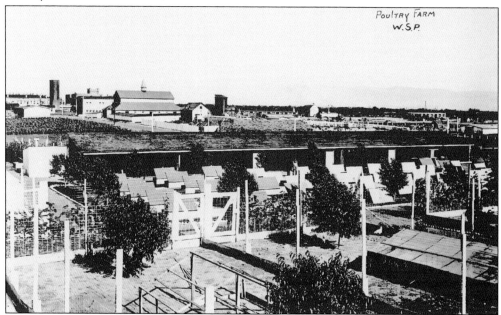

In 1921, a new state administrative code went into effect. Capital punishment was reestablished and so was a parole board. Numerous services were established that the penitentiary, as the main state prison, would supply to the other prisons and state institutions. This poultry farm supplied eggs and chickens to the state correctional institutions.

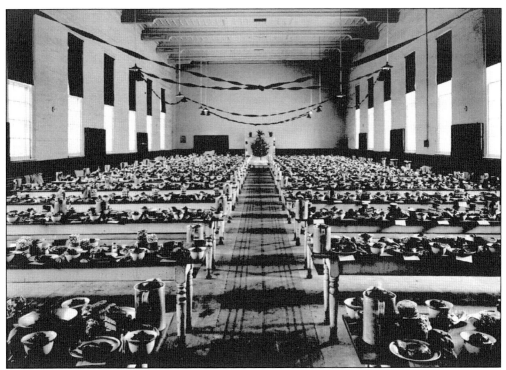

In this Christmas c. 1921 photo, inmates received a small dose of Christmas cheer in the inmates' dining hall. In 1935, the "chow hall" would be remodeled into a cafeteria-style facility. The kitchen was expanded at the same time.

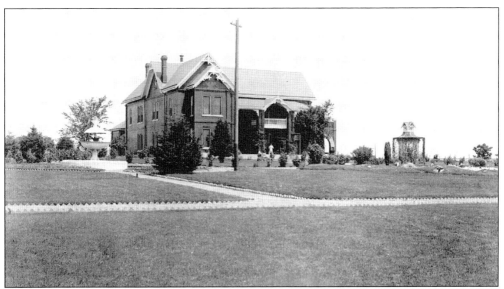

A house was constructed for the prison warden in 1888, so the prison's highest official could live near the grounds. That building was replaced in 1893, and a photo gallery was added. This picture of the wardens' home was taken about 1921, when A.F. Kees was warden. The building would be rebuilt again in 1938.

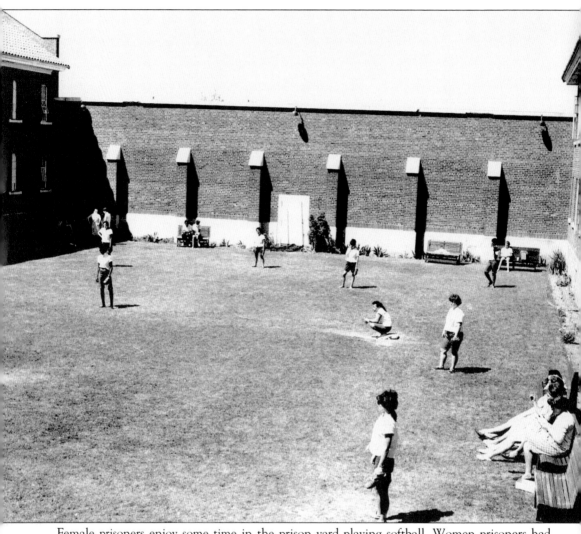

Female prisoners enjoy some time in the prison yard playing softball. Women prisoners had been kept at the Walla Walla Penitentiary since 1887, though in far smaller numbers than the men. It wasn't until about 1930 that a specific "Women's Quarters" was built. The prison no longer houses female prisoners.

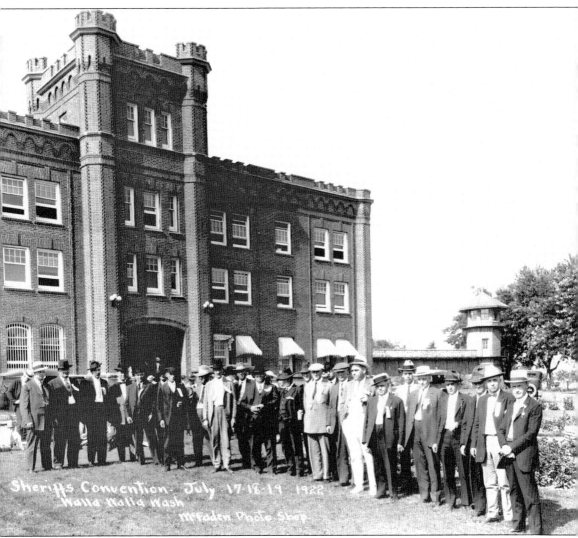

In 1922, the state sheriff's convention was held in Walla Walla. The attendees met at the Commercial Club where they were addressed by Maj. Ben F. Hill. This picture of the sheriffs was taken in front of the main administration building at the penitentiary. Sheriffs met to discuss law enforcement issues such as liquor laws and the parole system.

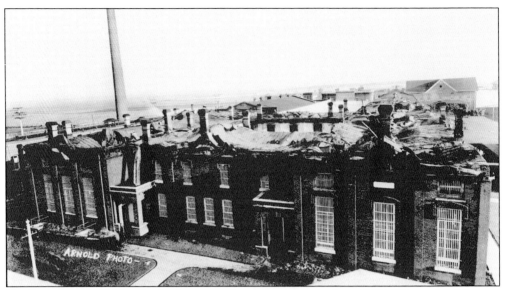

On September 3, 1926, a fire broke out at the prison, causing about $100,000 worth of damage to the roofs of five wings. The fire was likely caused by inmates putting burning pieces of cloth into the ventilation system. The next day, prisoners tried to set fire to the license plate plant, but the plot was foiled.

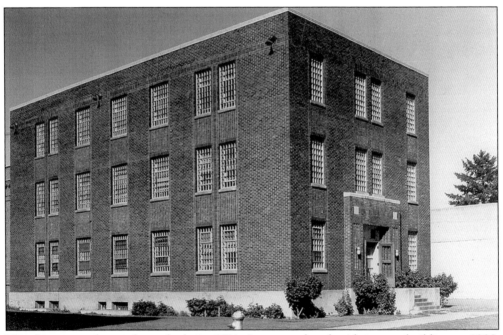

The first prison hospital was built in 1891. It was replaced with a new building c. 1908. This picture is of the same prison hospital, with its expansion completed in 1934. More equipment was installed at the same time. The hospital was modified again in 1960, when more beds were added.

$50.00 REWARD $50.00 REWARD

Referred to.....................

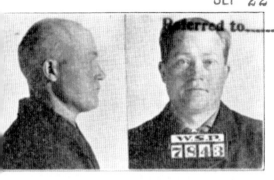 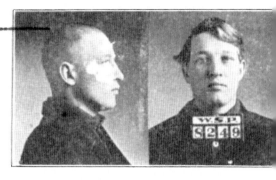

PAROLE VIOLATOR

WASHINGTON STATE PENITENTIARY, WALLA WALLA WASHINGTON.

No. 7843,-CHARLES ANDERSON, alias John Knudson,
John McNuttson.

DESCRIPTION-, Age 35. Height 5' 5 1/8".Weight 155. Hair
Light Brown. Eyes Hazel. Build Stocky. Complexion
Medium, Occupation Cabinet Maker. Nativity Norway.

MARKS AND SCARS-, I. Oblique cut scar 2" long 4½" above
wrist joint front left. III. Horizontal cut scar
3" above 1" back top right ear.

BERTILLON, -

65-5	19-4	24-6
60-0	15-4	10-6
91-0	14-4	8-1
	5-7	41-8

FINGER PRINT CLASSIFICATION.- 1 U IO 7
 1 U IO

REMARKS, - Received from Pierce County, Sept. 30th, 1915
Crime Assault 2nd Degree. Term 1 to 15 years.

RECORD, - Paroled 8-7-1918. Violated Parole 9-5-1918.
Has served a term in Oregon State Penitentiary as
#5668.

$50.00 REWARD will be paid for his arrest and delivery
to an authorized officer of this Institution.

ARREST AND WIRE, HENRY DRUM, SUPERINTENDENT.
WASHINGTON STATE PENITENTIARY. WALLA WALLA, WASHINGTON.

PAROLE VIOLATOR

WASHINGTON STATE PENITENTIARY, WALLA WALLA, WASHINGTON

No. 8249, L.A. STEURNAGLE.

DESCRIPTION, - Age 23. Height 5' 6½". Weight 146. Hair
Light Brown. Eyes Light Grey. Build Medium
Small. Teeth Good. Complexion Light. Occupation
Farmer. Nativity Minnesota.

MARKS AND SCARS, - Vaci scar 7½" below shoulder joint
outer. Small mole 4" above wrist inner left.
III. Small brown mole ½" back top left ear.

BERTILLON, -

68-9	19-0	24-7
66-0	14-5	11-2
92-0	13-9	8-8
	6-2	43-5

FINGER PRINT CLASSIFICATION, - 25 I 18
 1 00

REMARKS, - Received from Chelan County, March 4th, 1917.
Crime Grand Larceny, Term 1 to 10 years.

RECORD, - Paroled 6-15-1918. Violated Parole 8-26-1918
Has served term in Washington State Reformatory
as #1669.

$50.00 REWARD will be paid for his arrest and delivery
to an authorized officer of this Institution.

ARREST AND WIRE, HENRY DRUM, SUPERINTENDENT.
WASHINGTON STATE PENITENTIARY. WALLA WALLA, WASHINGTON

Wanted posters were common across the west in the "wild, wild west" days. Though those
lawless times were gone by 1918, the west still had its share of bad men. This wanted poster was
issued September 22, 1918, by the Washington State Penitentiary in Walla Walla. The two
men pictured, Charles Anderson and L.A. Steurnagle, were both wanted on parole violations.

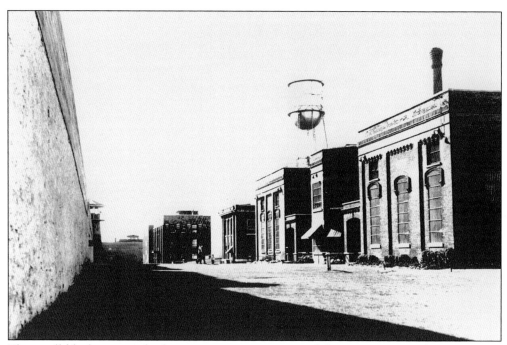

These cell blocks are inside the maximum security area of the penitentiary. The picture was taken c. 1950, though these cell blocks are much older than that date. Cell blocks were added in 1888, 1891, 1893, 1899, 1905, and 1932.

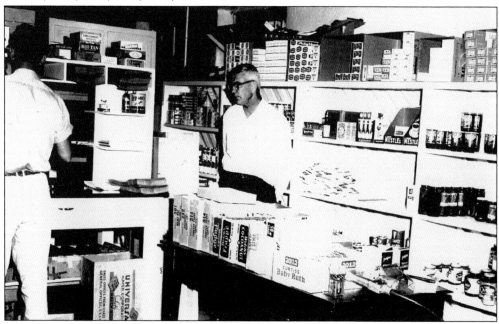

Inmates earn a stipend performing various job functions around the penitentiary, such as manufacturing license plates and road signs at the metal plant. Inmates can also receive money sent to them by family members. Money is placed on the inmate's account, from which he can draw to purchase items from the inmate store. Pictured is inmate Frank Williams, one of the store clerks who filled orders and inventoried the stock.

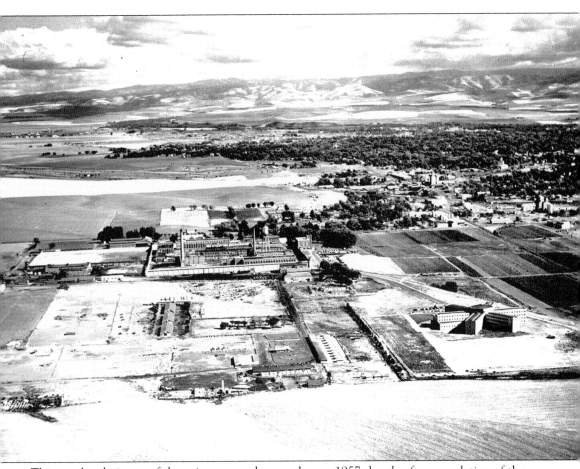

This overhead picture of the prison grounds was taken *c*. 1957 shortly after completion of the new minimum security area (the white building with five "spokes"). This building is known as the Blue Mountain Unit and is now a medium security facility. An industrial area had also been recently completed. The prison grounds also contained a hog farm and a poultry farm.

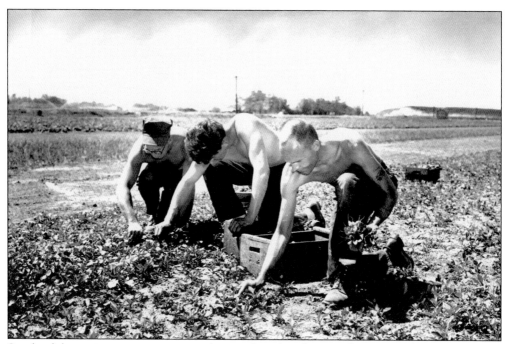

South of the main penitentiary is a substantial garden that supplies vegetables for the prison kitchen. This picture from the 1960s shows minimum security prisoners tending the garden, picking what looks like radishes.

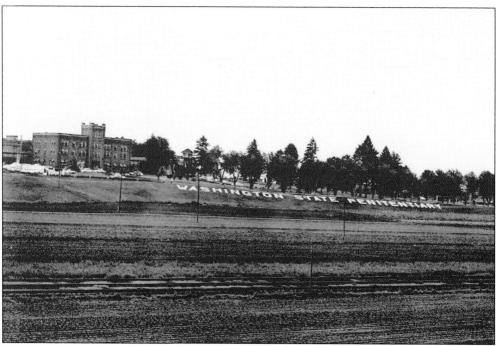

This is the main administrative building at the penitentiary. It has been remodeled somewhat from the original structure, but is still made of brick. The large block letters on the hillside in front let both visitors and staff know exactly where they are. The picture is from the 1960s.

Three

THE GROWTH OF
WALLA WALLA

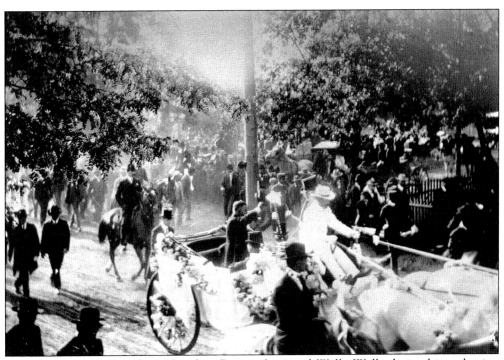

On May 25, 1903, President Theodore Roosevelt visited Walla Walla during his reelection campaign. The President's carriage led a parade down Main Street to Whitman College. With him were newly elected senator Levi Ankeny from Walla Walla; the President's secretary, William Loeb; and Gov. Henry G. McBride. The entourage was escorted by prison warden A.F. Kees.

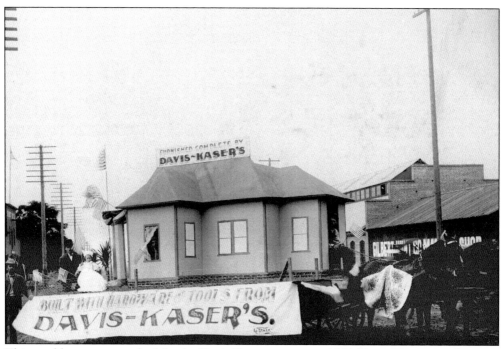

This pre-fab structure was built by the Davis-Kaser company in 1904. Davis-Kaser was a furniture company owned by John Davis and his father-in-law, Fred W. Kaser. The building may have been used as a float in an Independence Day parade. Gilbert Hunt Manufacturing Company has sales and construction offices to the left and right of the float, pictured on Main Street near Seventh Avenue.

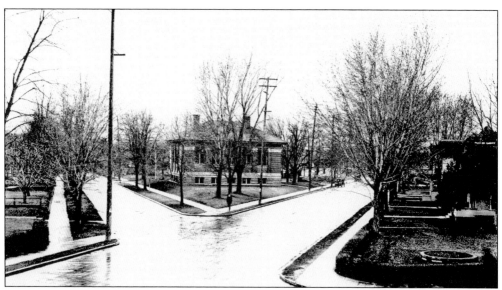

When philanthropist Andrew Carnegie established funding for libraries around the country, Walla Walla was one of the recipients. The land was donated by T.C. Elliot, a local banker. The Carnegie Library was completed in 1905 at the corner of Alder and Palouse Streets, in the center of the picture. In 1975, the building was placed on the National Register of Historic Places.

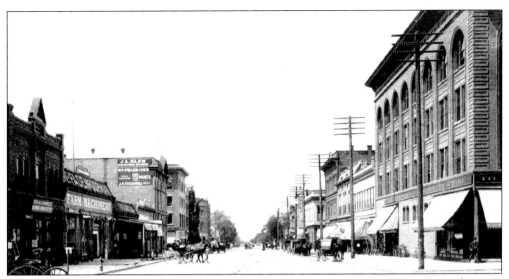

This c. 1905 photo of Alder Street looks west from First Street. Cox and Barnett Hardware & Farm Machinery is in the left foreground. J.L. Elam Agricultural Implements, the W.P. Fuller & Company, and J.H. Stockwell are west of it. The Deal Rite Department Store is opposite the hardware store.

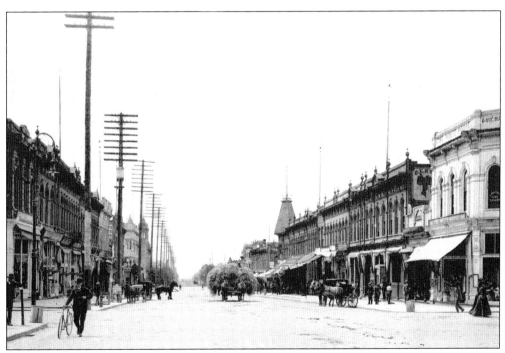

This view of Main Street also dates from c. 1905. The electrical poles are a clue to this date. The Northwest Gas & Electric Company built a hydroelectric dam on the Walla Walla River in 1904, and electricity was brought to the city in 1905. This view looks west down Main Street from Third Avenue.

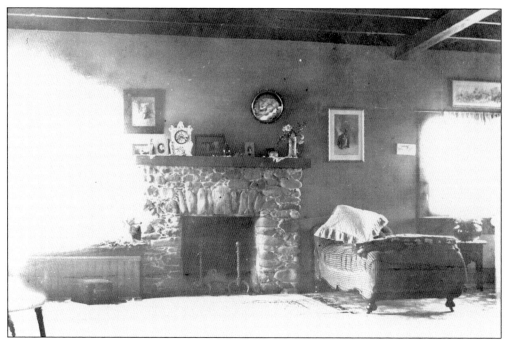

This early residence with a stone fireplace in the living room is at the home of Dr. Walter and Nora Ely, located at 155 Thorne Avenue. This photo is dated c. 1907. Dr. Ely's office was located in the Denny Building, where he practiced until 1917.

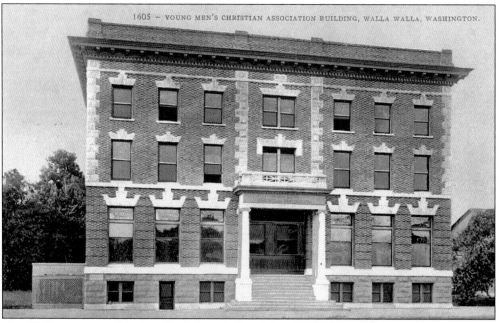

1605 – YOUNG MEN'S CHRISTIAN ASSOCIATION BUILDING, WALLA WALLA, WASHINGTON.

The YMCA was completed in 1907, though the association had existed since 1886. A $20,000 donation by Mrs. Lettice Reynolds ensured completion of the new building. The building had a gym, handball courts, reading rooms, and restaurant. F.D. Applegate was the physical director. The building is located at 28 South Spokane Street and is still in use today.

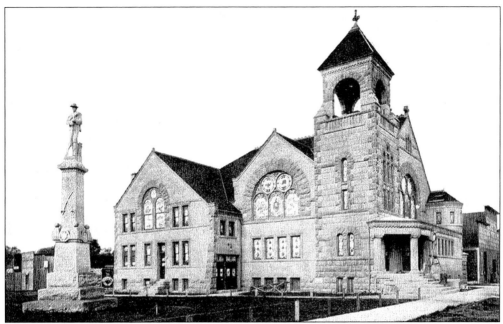

The Central Christian Church, located at Alder and South Palouse Streets, was completed in 1905 and dedicated on March 10, 1907. A memorial, at the left of the picture, is dedicated to seven local men who served in the Spanish-American War. It was erected on the property on July 4, 1904, before the church was erected. The building is still operated by the Central Christian Church.

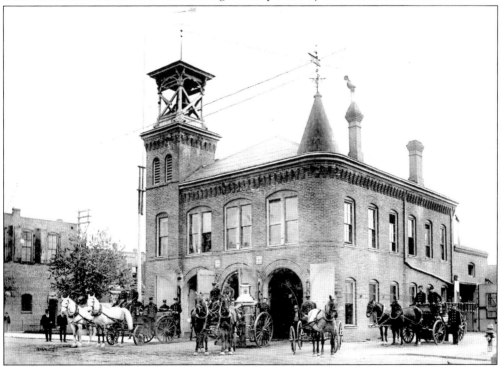

This picture of the Walla Walla Fire Department was taken in 1907. Fire Station No. 1 was located at Third Avenue and Rose Street.

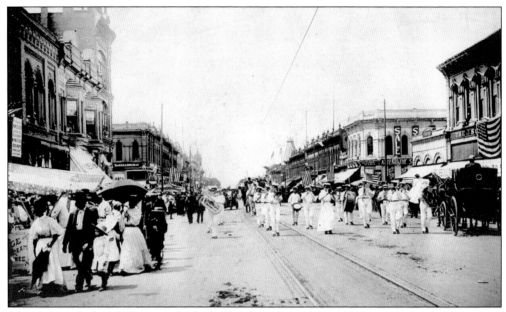

The events of July 4, 1908, were kicked off with a 13-gun salute. There were band concerts, an Indian exhibition, and, of course, this grand parade. The route took them down Main Street past Second and Third Avenues and up Alder Street. Besides these sailors, there were also floats representing many local businesses. There were also several "old" horse-drawn conveyances.

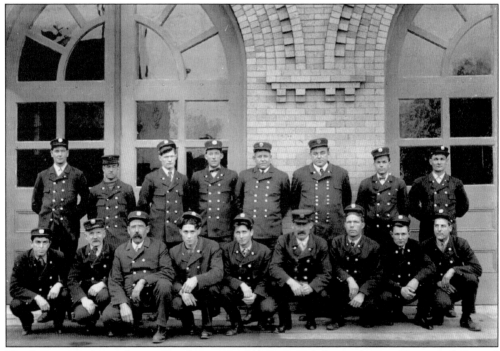

The firemen posing in front of headquarters in 1908, from left to right, are (front row) Seward Miller, Patsy Griffin, Jim Thornton, Frank DeGrace, Hugh Lyons, Will Davis, Will Strange, Tom Chapman, and Tom Casey; (back row) John Gunn, Nat Hart, Will Culp, Will Kohl, Bob Wolf, William Metz, Frank Dean, and Albert Griggs.

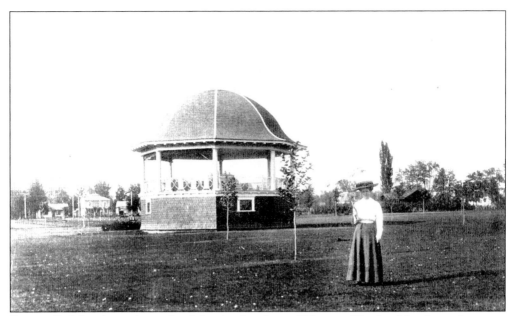

Pioneer Park has been the pride of the city for almost 100 years. The land for the park was set aside in 1901. In 1906, John C. Olmstead, the man responsible for developing Central Park in New York, designed a park plan for Pioneer Park. Located at Alder and Division Streets, the park was open to the public on September 6, 1908. This bandstand was built in 1909 so a band could play on summer nights.

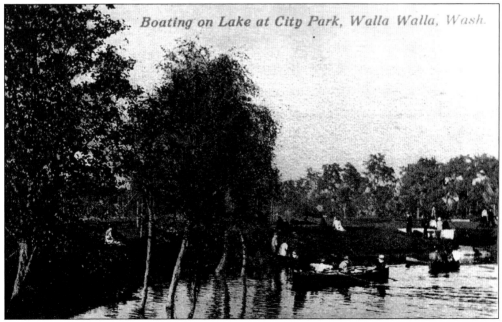

When the park was first selected, the property was mainly grass and weeds. Some local women formed a club to raise funds to improve the park. Eventually they raised enough money to build the bandstand. Their efforts also allowed the purchase of rowboats for the main lake. Later this large lake was separated into two smaller ones and a park road constricted between them. Rowboats are no longer allowed on either lake. One lake is now part of a small aviary.

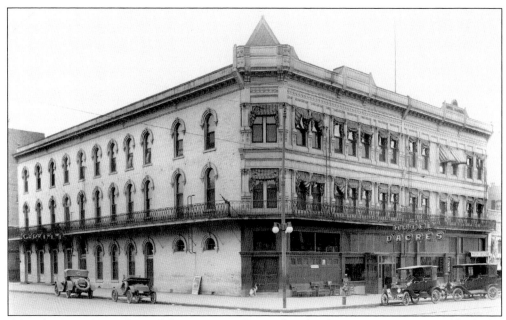

After the Stine House burned down, George Dacres bought the property in 1899 and built the Dacres Hotel. The hotel had a balcony on the second floor, bellhops to carry your luggage, a shoe black to polish your shoes, a barber shop, dining room and bar, and bathing facilities. During Prohibition, the bar was converted to a confectionery store. The hotel operated until May 25, 1963, and it was considered a "fancy" hotel.

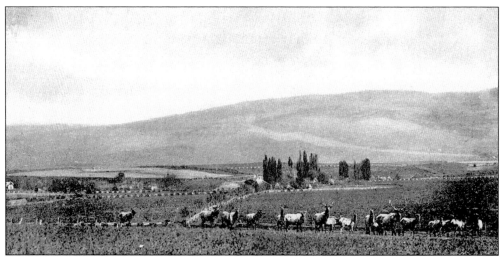

Reser's Elk Farm was located along the Walla Walla River. Bill and Byron Reser brought in Rocky Mountain elk from Yellowstone Park in 1910. They kept 35–40 elk on their cattle ranges. The elk grazed along the Walla Walla River and its tributaries. There is still a Reser Street that traverses the south side of town.

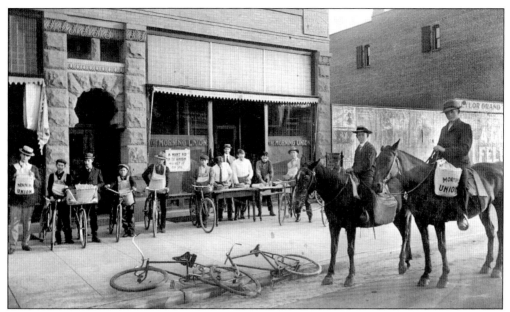

The *Morning Union* was established in 1869. In 1910, about the time this picture was taken, John G. Kelly bought the *Walla Walla Bulletin*, a rival paper. The two papers would merge in 1934. Its office was located on Alder Street between Second and Third Streets. These paper boys had to go to the newspaper office to get their morning deliveries, unlike modern times, when papers are taken to the boys' home.

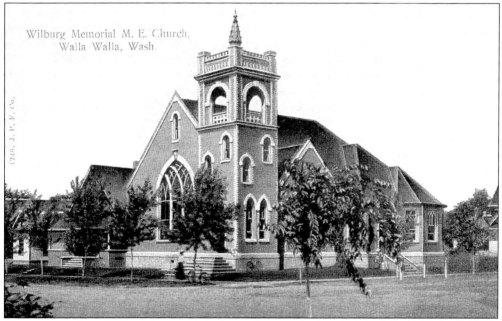

This picture of the Wilbur Memorial Methodist Episcopal Church dates from 1911. The church is named for Rev. J.H. Wilbur, founder of the first church built in Walla Walla. The first building was completed in 1860 at Alder Street and Fifth Avenue. In 1868 it was moved, and in 1878 a new building was erected. In 1894 it was enlarged again, and in 1909 it was moved to Colville and Poplar Streets.

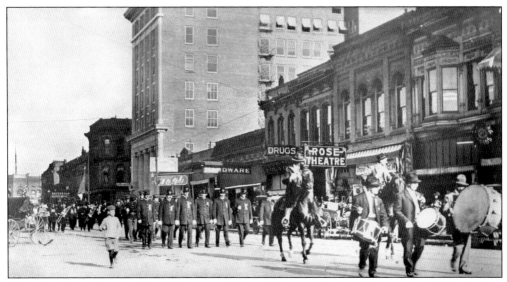

Columbus Day, October 12, 1911, was celebrated in grand style. This parade, led by Italian drummers and followed by local police and firemen, companies of soldiers, and local dignitaries, wound its way through town before arriving at the courthouse, where a statue of Christopher Columbus was erected. Tony Locati was the grand marshall of the parade.

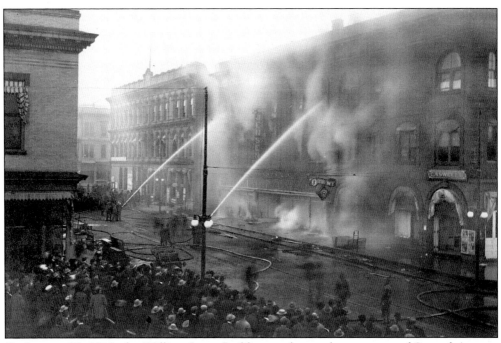

On January 26, 1912, the William Jones Building at the northeast corner of Second Avenue and Alder Street was destroyed by fire. The fire started in a corner of the basement and quickly spread until three floors were consumed. The building had stood since 1883. The fire caused $150,000 worth of damage. The A.M. Jensen Dry Goods Store lost $75,000 worth of merchandise by itself.

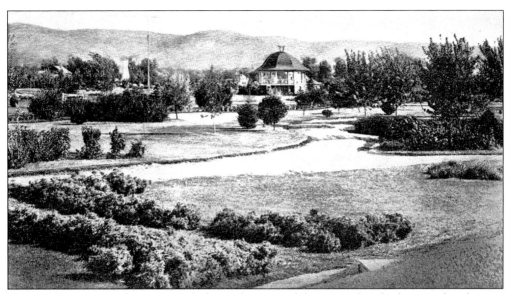

This c. 1912 picture of Pioneer Park shows that part of the original park plan was the planting of thousands of trees and shrubs. The women's park club planted sycamores all around the bandstand. The trees have grown substantially from the saplings.

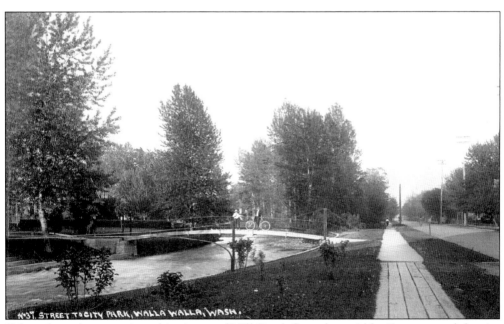

Taken about the same time, this picture of Mill Creek flows down Alder Street toward the city park. This foot bridge has long since disappeared from the landscape.

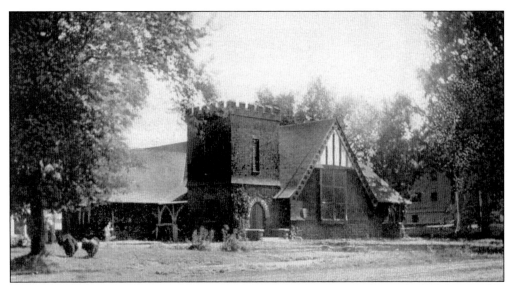

St. Paul's Episcopal Church was first organized in 1871. This Gothic-style building at 339 Catherine Street has housed the church since about 1902. This photo dates from about 1912. St. Paul's also had a school for girls, established in September of 1872 by Rev. L.H. Wells. Wells had previously held services in the old courthouse.

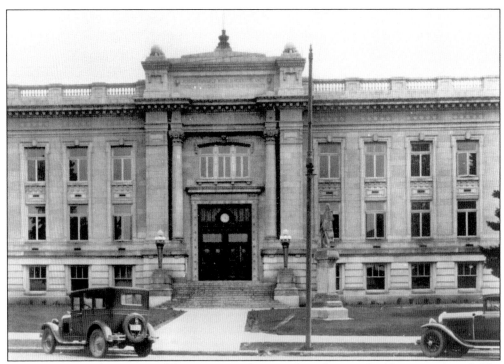

This county courthouse existed from 1881 until 1914, when this new building was erected. The first courthouse was condemned in 1913. The 1891 Hall of Records faces Fifth Street and is now used as the law library. On the other end of the court house is the 1906 county jail and the sheriff's office. The statue of Christopher Columbus was erected in 1911 by Italian descendants who personally paid $1,000 for the sculpture.

The first Baker-Boyer Bank was built in 1869 at Second and Main Streets. Due to the need for expansion, Baker-Boyer Bank was rebuilt and opened in this new building at 7 West Main in 1910. The seven stories have a Roman Ionic design exterior, part of a Neo-Classical Revival style. The columns and capitals were carved from sandstone.

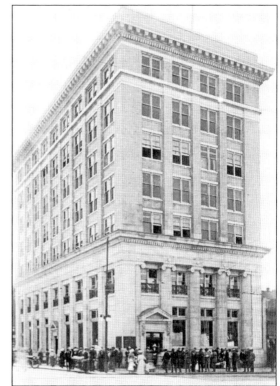

Walla Wallans enjoy using parades to celebrate events, and residents turn out in droves to watch them. This parade, featuring a marching band, makes its way down Main Street. This photo dates from about the 1910s. There are no horseless carriages in view.

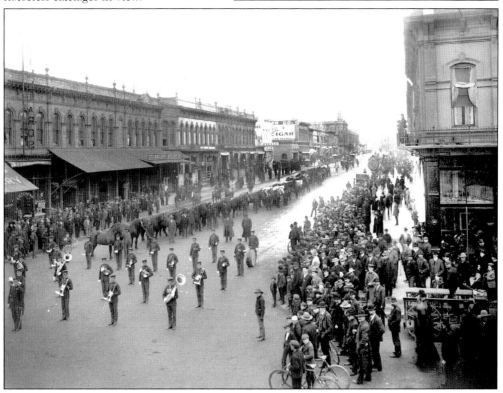

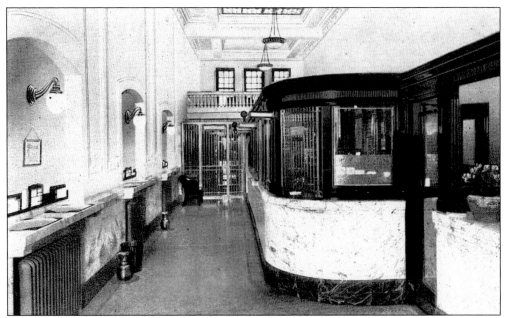

People's State Bank was located at 18 East Main Street and managed by president H.H. Marshall. Before 1911, it was known as Elam Bank, owned by J.L. Elam. It first opened in 1904 at First Avenue and Alder Street. It closed on September 14, 1932, because of the Depression. Shortly before the closure, the bank president committed suicide.

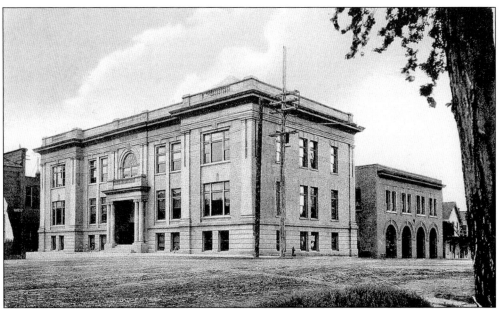

The city hall building at Third Avenue and Rose Street was completed in 1908. The building was designed by Harry Osterman. The first floor was occupied by the police department. The second floor contained the city offices. The third floor was used by the Commercial Club. The building is still in use by the city.

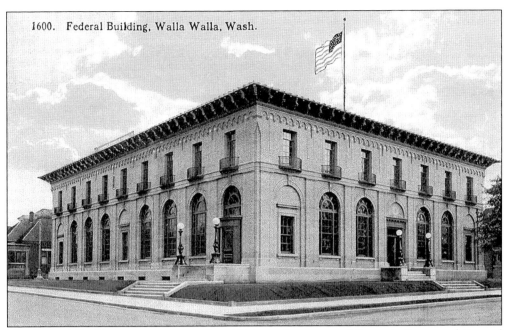

1600. Federal Building, Walla Walla, Wash.

The Federal Building was constructed in 1914 on the corner of Sumach Street and Second Avenue. It has served many purposes over the years, including federal court and weather bureau. Today it serves mainly as the city post office.

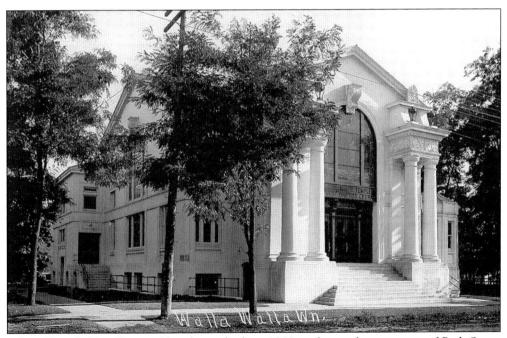

White Temple First Baptist Church was built in 1912 at the southwest corner of Park Street and Boyer Avenue. U. Grant Fay of Seattle was the architect. The church existed until 1991.

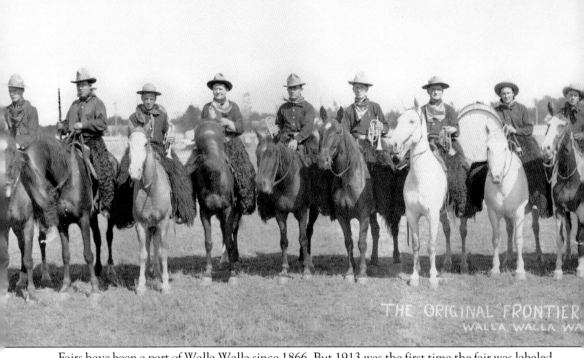

THE ORIGINAL FRONTIER
WALLA WALLA WA

Fairs have been a part of Walla Walla since 1866. But 1913 was the first time the fair was labeled "Frontier Days." Quite a production was made that year with an elaborate parade that had wagon trains, marching bands, and farm machinery. Nancy Jacobs and O.F. Canfield, survivors of the Whitman Massacre, held honored places in the parade. There were a number of races, including a stage coach race and a cowboy relay race. There were numerous rodeo events such as steer roping and bull riding. Through it all this horseback-bound marching band entertained a crowd that numbered in the thousands.

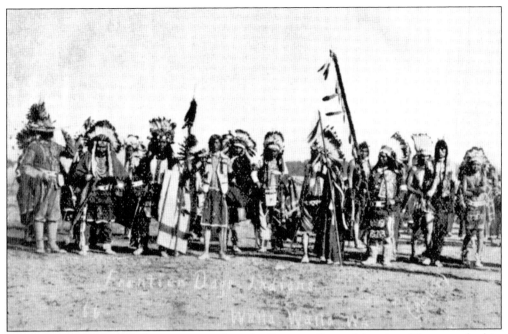

Native American tribes also participated in the Frontier Day celebration. They marched in the parade and participated in various events such as horse and foot races. These tribes were members of the Walla Walla, Nez Perce, Umatilla, and Yakama nations.

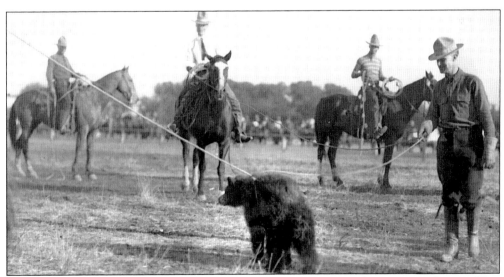

One of the more unusual events at the 1913 Frontier Days was bear-roping. George Weir participated in the event, roping the first animal. Frank Roach caught the second after a long chase. In this picture, two men have the same bear in their lassoes.

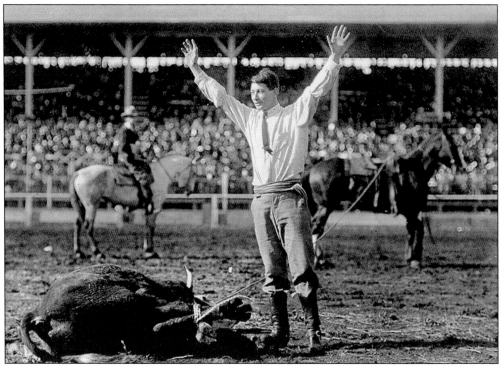

Frontier Days in 1914 was celebrated with a parade, stagecoach races, bull-riding, chariot races, and other events. Steer roping was one of the most popular events. Frank Roach and Jack Mabey got the best times, roping their steers in less than a minute and a half each. Women also participated in the event.

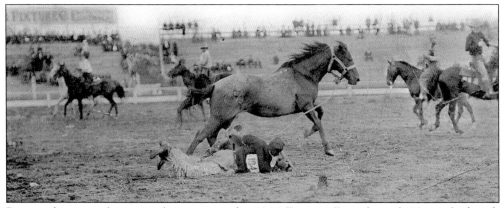

Bronc-riding was also a popular event at the 1914 Frontier Days festival. Horses had such colorful names as Monkeywrench, Entertainer, Snowbank, Dutch Jake, Barbwire, Red Devil, Blue Streak, and Blackhawk. Here, Clarence Plant fell off his horse Blue Blazes when his saddle girth broke and he sailed over the horse's head.

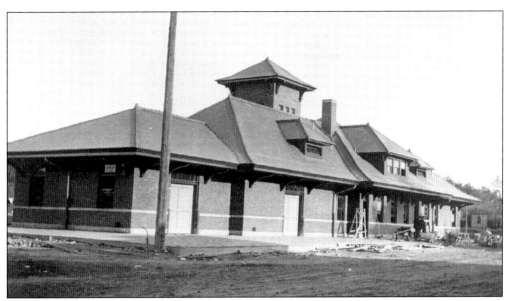

This picture of the Northern Pacific Depot was taken on November 8, 1914. This depot was located on Second Avenue. The old building has been restored and now serves as Jacobi's Train Car Cafe.

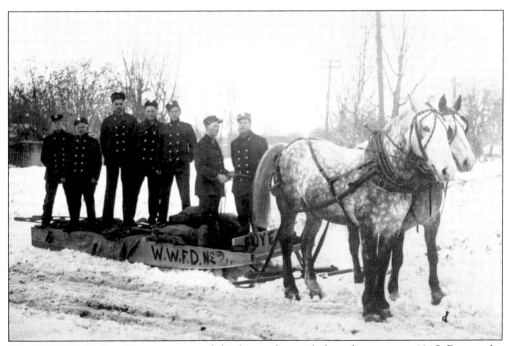

The Walla Walla Fire Department used this horse-drawn sled as a hose cart in 1915. During the winter months it was easier to pull a sled rather than a wagon through the snow. Tom Casey is the fireman on the far right.

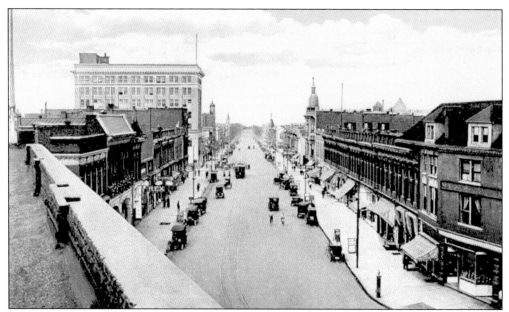

This bird's-eye view of Main Street dates from approximately 1915. The view faces west from the intersection of Main Street and First Avenue. The picture is taken from the roof of the Die Brucke building in the left foreground. The tall building in the left background is the Baker-Boyer Bank. There are no horse-drawn conveyances in the picture, but motor vehicles still share the road with streetcars.

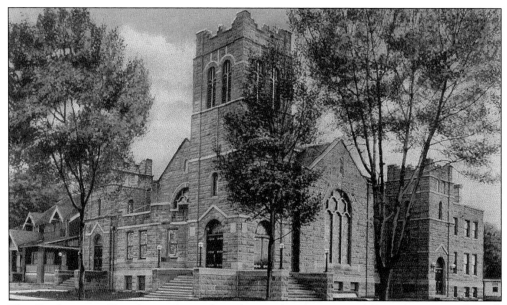

The Presbyterian Church was located at the southeast corner of First Avenue and Birch Streets, and its cornerstone was laid on September 11, 1912. The new building was needed to accommodate the consolidated parishes of Cumberland and First Presbyterian, which merged in 1907.

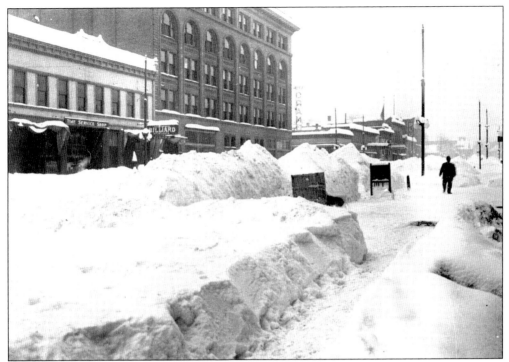

Between December 22, 1915 and February 6, 1916, 77 inches of snow fell in the valley. One 56-hour period between January 31 and February 3 dumped 28 more inches on the ground. Here snow is piled up on Alder Street, looking east from about Second Avenue. Relief came in the form of a Chinook wind, which arrived on February 7 and melted the snow.

The first St. Mary's Hospital was built at Seventh Avenue and Poplar Street and opened in 1880. The first Sister Superior was Mother John of the Cross. That building burned down on January 27, 1915. The cornerstone of this new facility was laid September 26, 1915. Robert F. Tegen from Portland, Oregon, was the architect of the new building. This building would be replaced again in 1976.

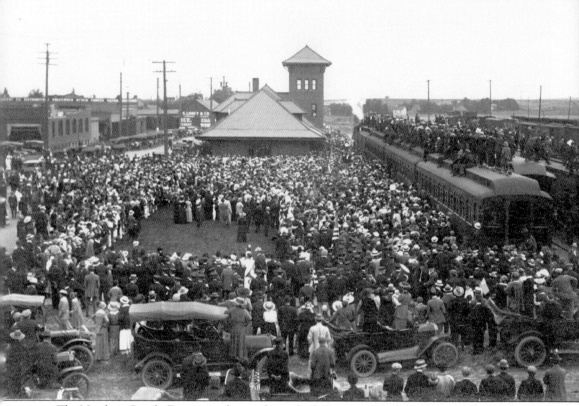

The Northern Pacific Depot was the site from which Company K of the National Guard departed for service. This picture dates from June 23, 1916, when thousands assembled at the depot to see the soldiers, led by Capt. Archie W. French, off at 5 a.m. The Elks, IOOF, Spanish War veterans, and many others were in attendence to send off the troops. Their mission would be to guard the Mexican border.

Order of Induction into Military Service of the United States.

THE PRESIDENT OF THE UNITED STATES,

To _____Paul_____ _____Thonney_____
 (Christian name.) (Surname.)

Order Number _____1705_____ Serial Number ___398___

Greeting: *Having submitted yourself to a local board composed of your neighbors for the purpose of determining the place and time in which you can best serve the United States in the present emergency, you are hereby notified that you have now been selected for immediate military service.*

You will, therefore, report to the local board named below

at _____Court House_____, at ___10___ A m.,
 (Place of reporting.) (Hour of reporting.)

on the___7th___ *day of*_____October_____, 19 18,
for military duty.

From and after the day and hour just named you will be a soldier in the military service of the United States.

C. F. Dermont

Member of Local Board for _____

*Report to Local Board for*___Walla Walla County___

___Walla Walla___

Date ___Sept 25, 1918___ ___Washington___
Form 1028. P.M.G.O. (See Sec. 157. S. S. R.)

This document is a draft notice for Walla Walla resident Paul Thonney. Thonney was ordered to report to the Walla Walla draft board on October 7, 1918, for service during World War I. Fortunately for him, the war ended a short time after his draft, on November 9, 1918. He received his honorable discharge on December 18, 1918. Thonney was a farmer and 26 years old at the time of his enlistment.

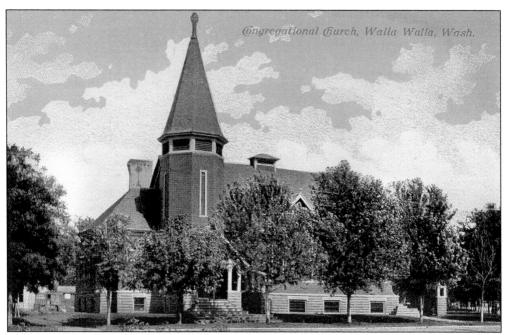

The First Congregational Church was located at South Palouse and Alder Streets. The church, organized in 1864, was the first one in Washington. The church had 292 members when this building was dedicated in 1900, and land for the new building was donated by Mabel Baker Anderson. This building was burned down in 1922 and replaced several years later with a new structure.

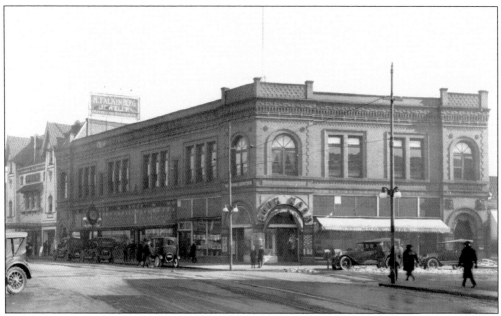

The Book Nook and Kristian Falkenberg, Jeweler stand at this location at Main Street and First Avenue. The Book Nook occupies the Die Brucke building, built in 1903 by Max Baumeister. The building stands on the site of the first fort built in 1856. This picture dates from approximately 1923.

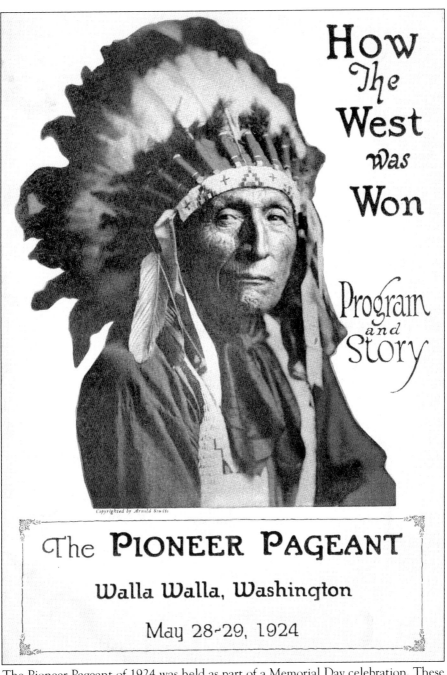

How
The
West
was
Won

Program
and
Story

Copyrighted by Arnold Studio

The PIONEER PAGEANT

Walla Walla, Washington

May 28-29, 1924

The Pioneer Pageant of 1924 was held as part of a Memorial Day celebration. These special programs were printed by the Walla Walla Pageant Association, Inc. to commemorate the event. The pageant depicted Northwest history beginning with the Lewis and Clark exploration to the building of the first western railroad in 1875. The three-and-a-half hour performance was punctuated with Indian battles, gorgeously designed sets, and fantastic dancers. The pageant was directed by Percy J. Burrell of Boston and was held at Pageant Field. The script was written by Whitman College president Stephen Penrose.

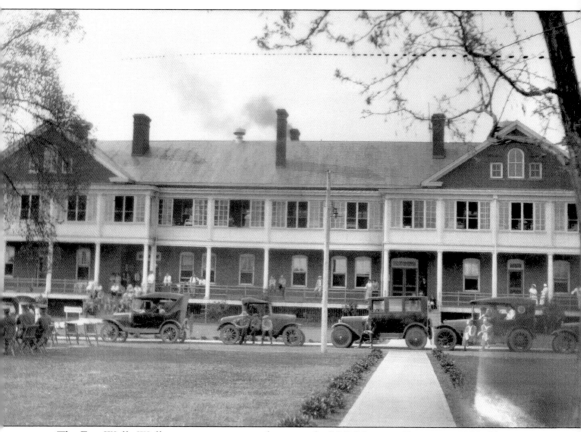

The Fort Walla Walla property was turned over to the U.S. Veterans Bureau in 1921. That winter, the remaining buildings were converted for use as a hospital. This is hospital building #68 or #69, both of which were infantry barracks. These barracks were built in 1906 at a cost of $60,955. They have been used over the years as patient wards and administrative offices. This and other buildings on the grounds were placed on the National Register of Historic Places in 1974.

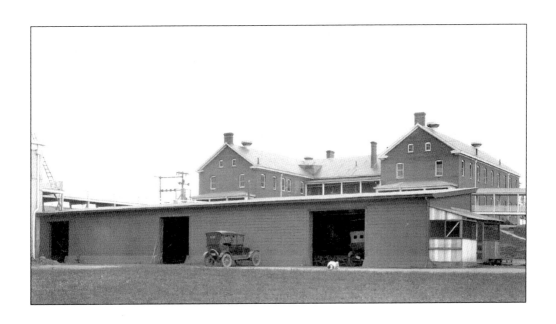

There were about 100 individual structures on the Veteran's hospital grounds. Most of the wooden structures remain from the days when the army occupied the post. Logs were hauled by wagon and horse from Mill Creek near Kooskooskie on the Oregon border and were milled on fort grounds by army soldiers. Above is building #58, which served as a coal shed at one time. Below is building #74. The hospital was later named Wainwright Memorial Hospital after Gen. Jonathan M. Wainwright.

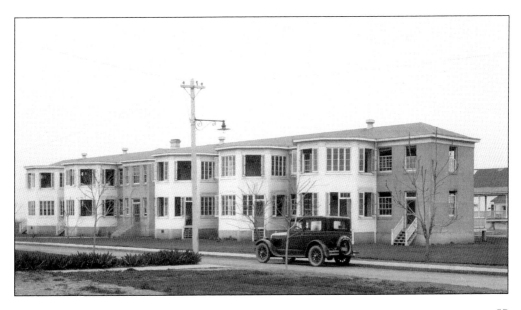

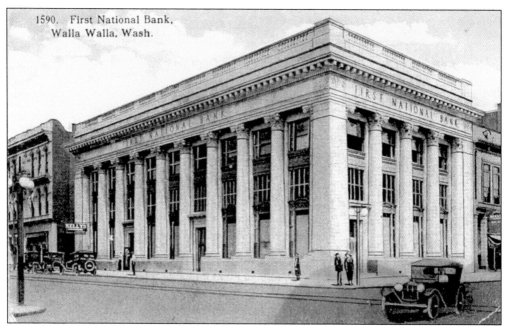

1590. First National Bank,
Walla Walla, Wash.

First National Bank stood at Second Avenue and Alder Street. The bank had elaborate Corinthian columns, a balustrade around the roof, and relief carvings. The bank first opened in 1908, and this picture dates from the 1920s. The building still stands on the same corner and is occupied by Banner Bank.

The first Walla Walla Hospital was located at Walla Walla College in nearby College Place. When the college was burned, the treatment facilities were moved to a new sanitarium on the college grounds. The hospital built this facility in 1927 at 933 Bonsella, after which it was known as Walla Walla General Hospital. That facility served until a new facility opened on South Second in 1977.

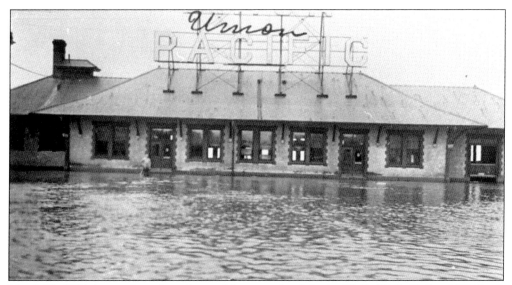

March 31, 1931, began three days of one of the worst floods in the Walla Walla Valley. Mill Creek overflowed its banks and pushed boulders down the streets. The sewer system was overwhelmed, and most of the street bridges were eroded away. The flood knocked out a water main, and the city had to borrow water from private businesses and the penitentiary. The flood waters reached the Union Pacific Depot located at the west end of Main Street at the edge of town.

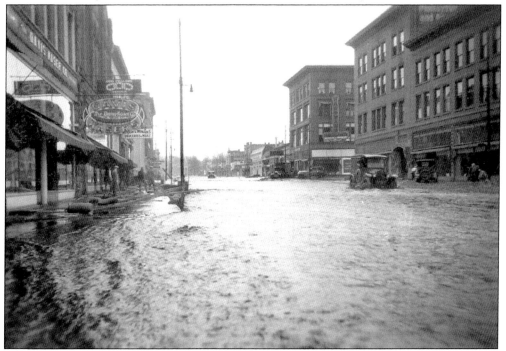

The IOOF temple can be seen on the left side of Alder Street, where the flood water surged down the street. St. Mary's Hospital suffered damage when its basement and power plant were flooded. The newspapers printing presses were damaged, so the paper had to be printed elsewhere. Amazingly, only one person died during the flood. It caused $1 million worth of damage.

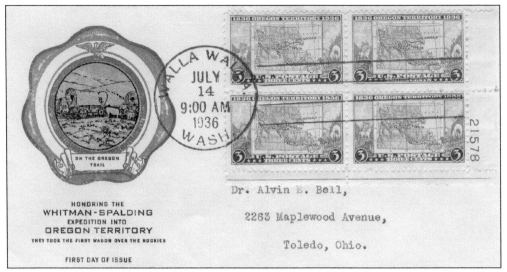

In 1936, the city held the Whitman Centennial, to celebrate the 100 years from when missionaries Marcus Whitman and H.H. Spalding first came to the Walla Walla Valley to minister to Indians. The celebration was held August 13–16 and included parades, a fireman's show, a pageant, races, and sporting events. This special commemorative first day cover was created by the local post office to celebrate the Whitman-Spalding Expedition.

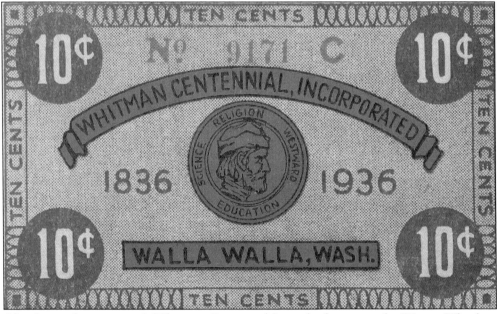

Also during the centennial, Whitman Centennial Inc., also known as the Wagon Wheelers, the organization that orchestrated the event, created these special coupons. They could be redeemed at the Union Bank and Trust Company for face value up until August 18, 1936, but were no longer valid afterward.

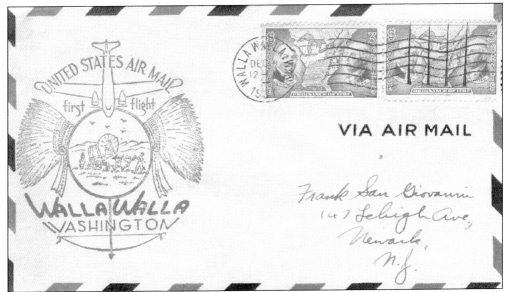

On December 4, 1937, planes from Portland and Pendleton arrived at the Walla Walla airport for the first air mail delivery. Ralph Gibbons, formerly manager of the Walla Walla airport, flew the plane from Portland. Ceremonies took place throughout the day and many regional dignitaries were invited. About 10,000 commemorative first flight letters were stamped with this special cachet to celebrate the event.

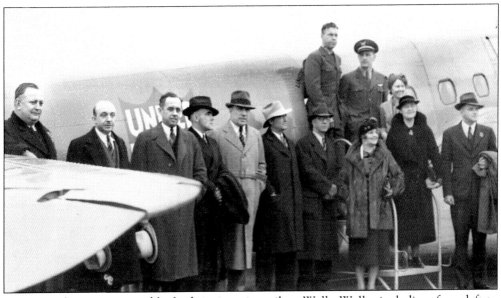

Many people were responsible for bringing air mail to Walla Walla, including, from left to right, Hainer Hinshaw, United Airlines official; Paul Morris, airport supervisor; Dr. Raymond Staub; H.F. McFadden; C.L. Lieuallen, mayor of Pendleton; J.K. Thompson; Capt. E.J. Smith, co-pilot; Capt. Ralph J. Gibbons, pilot; Billy Wilson, stewardess; George Strand; Mrs. A.H. Hawkinson; Mrs. R.J. Gibbons; and C.J. Middleton.

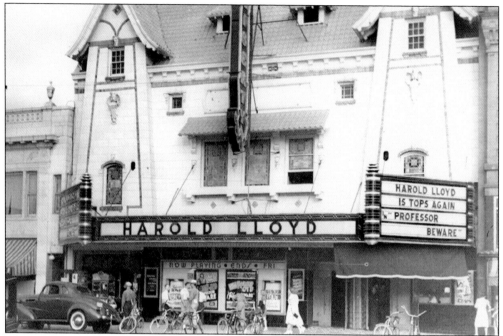

Liberty Theater on Main Street, between Colville Street and First Avenue, was originally built by Alexander Taylor and Richard Wassell in 1917. It was first known as the American Theater. It was remodeled and renamed in 1926. Various architectural enhancements were made at that time. The marquee shows that *Professor Beware*, starring Harold Lloyd, is currently playing, dating this photo *c.* 1938.

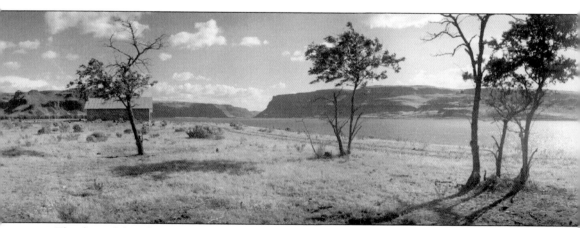

The date of this photo is unknown, but it is at least prior to the building of the Boise Cascade pulp mill at this location. This view, looking toward Wallula Gap, is the original site of Fort Walla Walla. This location is near the confluence of the Walla Walla River with the Columbia River. Foundation stones of the old fort still stood at this time.

Five

AGRICULTURAL BOUNTY

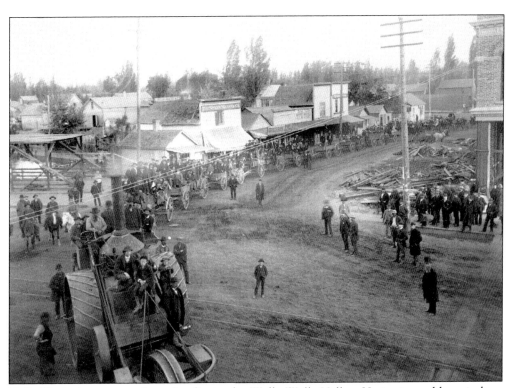

N.G. Blaylock was an early orchardist in the Walla Walla Valley. He is pictured here in long beard and top hat admiring his steam harvest machine. On this day in September 1890, the machine pulled 24 wagons full of nearly 800 children to the county fairgrounds. This picture was taken at First Avenueand Main Street.

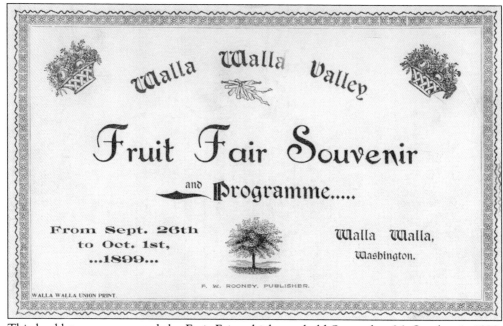

Walla Walla Valley

Fruit Fair Souvenir

and Programme.....

From Sept. 26th
to Oct. 1st,
...1899...

Walla Walla,
Washington.

F. W. ROONEY, PUBLISHER.

WALLA WALLA UNION PRINT.

This booklet commemorated the Fruit Fair, which was held September 26–October 1, 1899. As part of the fair, two couples got married at the fair pavilion. A band entertained fair-goers afternoons and evenings. Dozens of awards were given, including the best ears of corn, the best display of sugar cane, the largest squash, and the largest pumpkin.

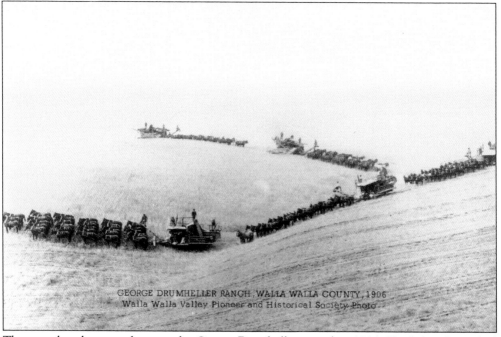

GEORGE DRUMHELLER RANCH, WALLA WALLA COUNTY, 1906
Walla Walla Valley Pioneer and Historical Society Photo

These workers harvest wheat on the George Drumheller spread in 1906. His father, Jesse, had accumulated 6,000 acres by the time he retired in 1899, turning over the operation to his family. The Drumheller property was located northwest of town off Sudbury Road. Machines commonly used in the wheat harvest are the header and the binder, as well as combination machines.

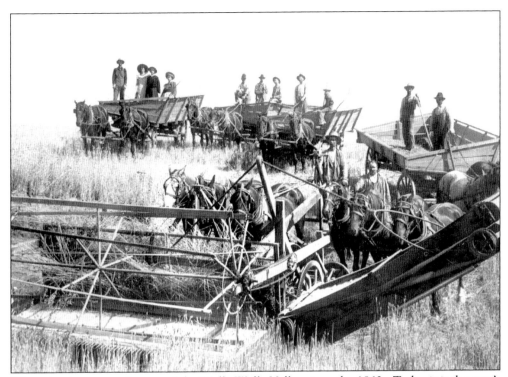

Wheat has been a staple crop of the Walla Walla Valley since the 1860s. Today it is the area's number one crop and accounts for about one-third of revenue from crops. Up to a quarter million acres are under cultivation at any given time. These farmers are harvesting grain the old-fashioned way, with horse power.

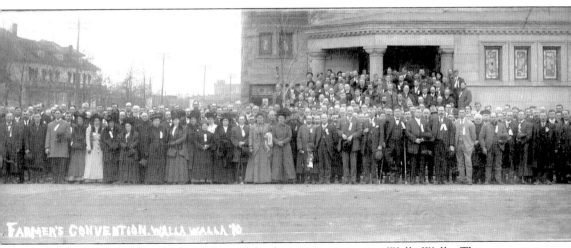

In January 1910, hundreds of members of the farmers union met in Walla Walla. There were six female members of the Walla Walla union, the first time women had been admitted. Mayor Tausick and Whitman College president Stephen Penrose addressed the farmers. Several sessions were held here at the Central Christian Church.

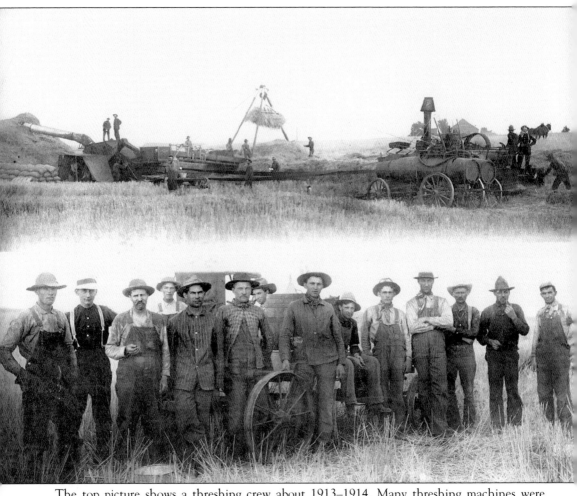

The top picture shows a threshing crew about 1913–1914. Many threshing machines were towed from one farm to another. Working with one could be a hard job as the operator was always wrestling with the dust and chaff that poured from the machines. The thresher knocked the grain kernels free and the chaff flew out the back. The lower picture shows men taking a break in front of a water wagon. Note the wheels of the farm equipment do not yet use rubber tires.

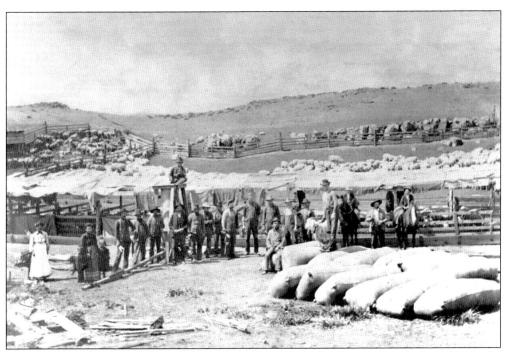

There were several sheep ranches in the vicinity of Walla Walla in the early days. The Jo-So Ranch was one of them. These men take a break from sheep shearing to pose for this picture. Large bags of wool have already been filled.

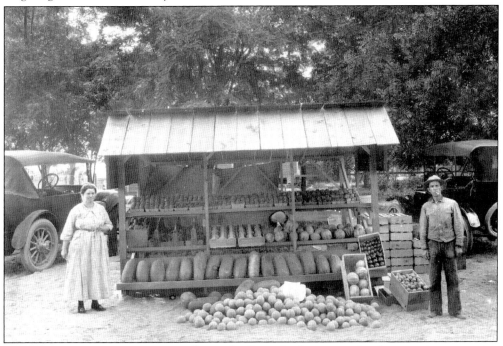

Some farmers grew crops on a smaller scale. Some had excess only after canning or storing enough for their own use. As in many areas, excess fruit and vegetables ended up being sold at roadside stands, such as this one from the 1920s.

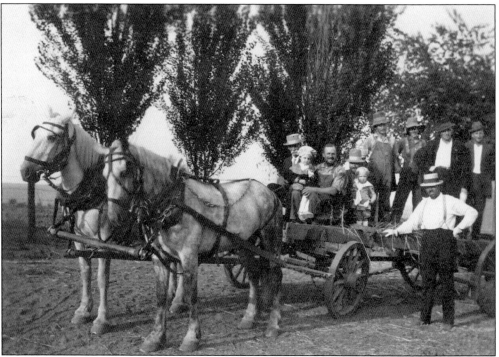

The Stubblefield farm was located on Yellowhawk Creek near modern day Fern Avenue. This picture of various crew members was taken about 1914 at the Stubblefield farm.

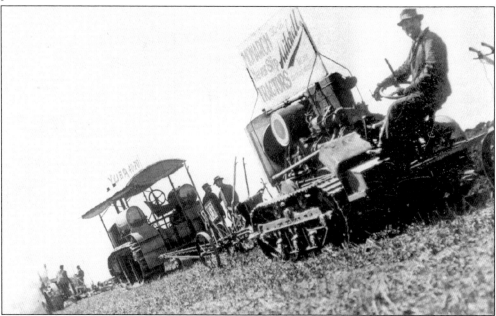

The Tractor Demonstration took place April 23–25, 1919. This photo was taken on the Harve Yenney farm, where the tractors plowed a field as part of the demonstration. The demonstration was hosted by the Pacific Northwest Tractor & Power Farmers Association of Spokane. Several filmmakers were on hand to film the demonstrations. Fordson, International Tractor, and Leader Crawler were some of the models displayed.

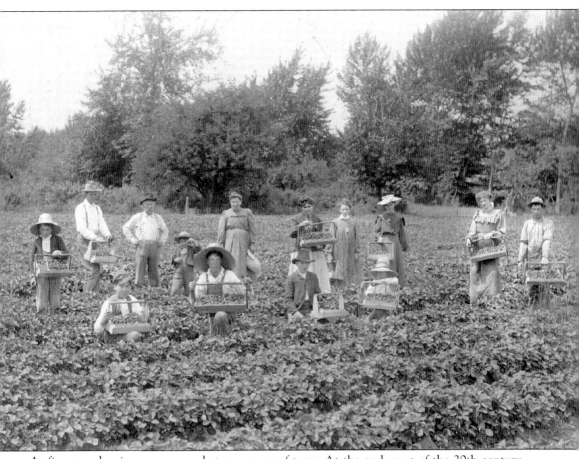

At first strawberries were grown between rows of trees. At the early part of the 20th century, there were only about 60 acres planted in strawberries. Jack and Delbert Klicker were the largest growers and had about 400 acres at one time. These workers are picking strawberries, a task that was largely done by hand rather than by machine.

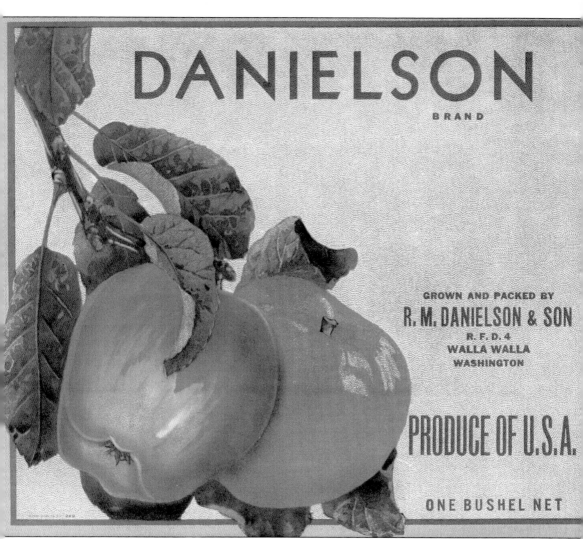

DANIELSON
BRAND

GROWN AND PACKED BY
R. M. DANIELSON & SON
R. F. D. 4
WALLA WALLA
WASHINGTON

PRODUCE OF U.S.A.

ONE BUSHEL NET

Apples played a small part of valley business. In the 1910s there was significant planting of orchards, with the peak of the apple business coming in 1924. After the Depression most trees were removed. The Danielson Apple Company, owned by Ralph Danielson, grew apples near Waitsburg, about 25 miles away, and packed them at Walla Walla. In 1955, a big freeze wiped out most of the apple orchards. The industry has never recovered.

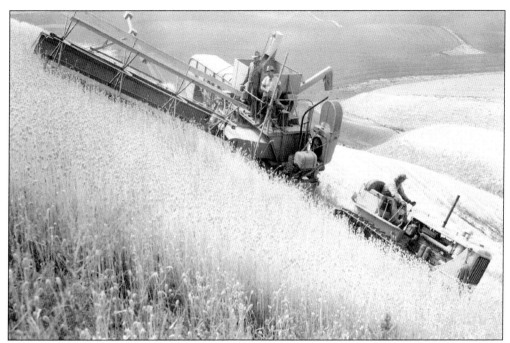

Ultimately horsepower was phased out in favor of mechanized farming and harvesting equipment. However, using mechanical equipment on such steep slopes could present its own challenges. Though residences and businesses line the river valley, many of the crops are grown on the surrounding hills.

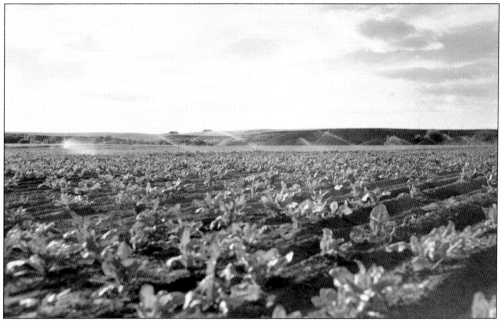

In March 1922, H.C. Rosenfelt of U&I Sugar Company visited Walla Walla to investigate the possibility of growing sugar beets in the area. Evidently the outcome was positive as several growers grew crops. However, beets never were a large money-making crop and today are grown in small amounts in private gardens.

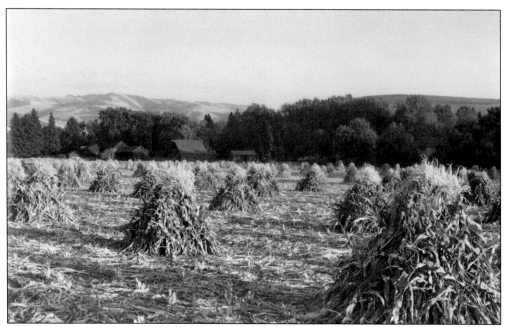

This corn field has been harvested and has been left in piles for drying. Corn has been planted in the area since the early days, but sweet corn has never done well here. However, other types of corn have been grown and canned by local canneries including Walla Walla Canning and Birdseye. Corn earworm has been a common pest in the past.

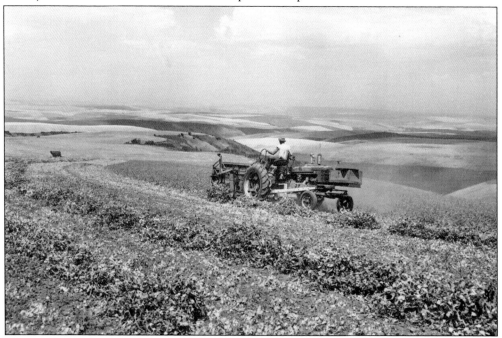

This swather picks peas from their vines in the 1950s. The cutter bar of the swather adjusts to the contours of the ground, then lifts the vines before cutting them. The pods are thrown on a canvas belt and stacked neatly in windrows. Peas are a relatively late arrival to Walla Walla's economy. In the early 1930s the first large-scale fields were planted and harvested.

Six

A Center
of Education

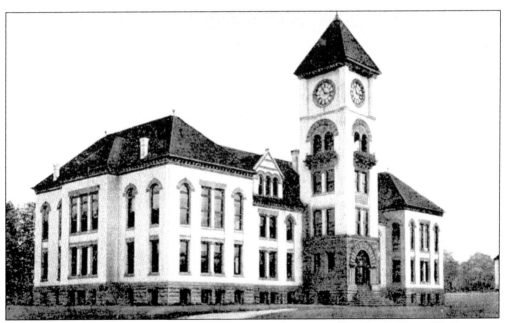

The Whitman Memorial Building was donated to Whitman College by Dr. Daniel K. Pearsons. The building cost $50,000 and is 111 feet tall. It was completed in 1899 and is the oldest building on the campus. Over the years the building has served many functions, including library, chapel, classrooms, and administrative offices.

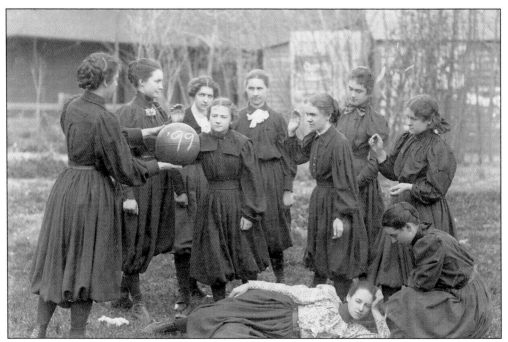

Here is the first girls' basketball team at Whitman College, 1899. From left to right are Eliza Ramsey, Annie Barrett, Melissa Thomas, Bethene Crayne, Orva Greene, Arminda L. Fix, Leonore Bailey, Irma Rupp, Mabel Kelso, and Alice Gentry.

Named for Dorsey S. Baker, Baker School was the first public school building in the Inland Empire. Baker donated the land between Cherry and Sumach Streets for this building, which was constructed in 1882. These school kids are from the fourth grade of 1902. Their teacher is Bonnie Jean Painter.

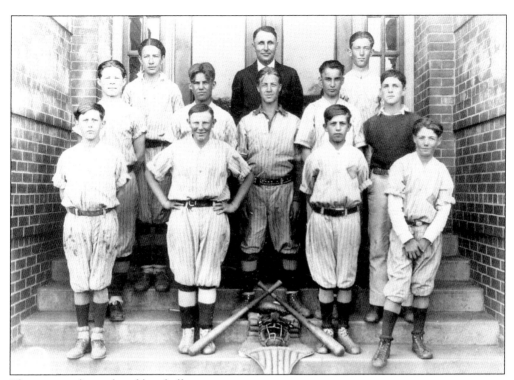

These young boys played baseball for Baker School. The school remained in operation until 1955, when it was demolished.

This picture of Sharpstein School dates from approximately 1906. The school, originally established in 1898, was located at Howard and Whitman Street. It was named for B.L. Sharpstein, who was a member of the school board when the various school districts were being consolidated in the 1870s. The school was recently renovated. It is the oldest continuously operating elementary school in Washington.

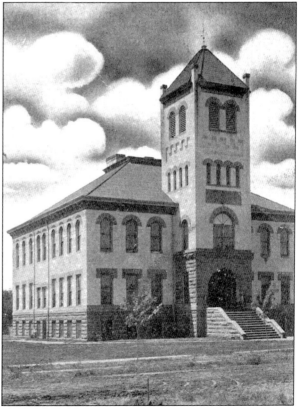

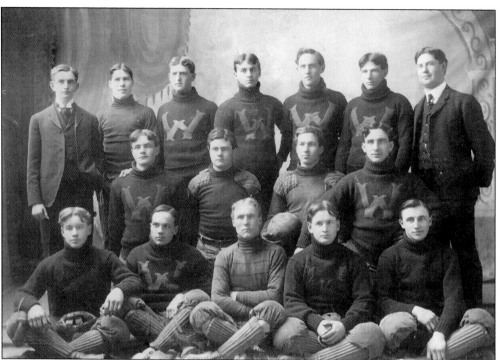

This is the Whitman College football team in 1904. From left to right, they are (front row) John Lyman, Elmo Reeser, Jim Lyman, Art Morgan, and Edward Morgan; (middle row) Spike O'Neal, Unknown, Roy Perringer, and Tom Dutcher; (back row) Sutherland, Job Rigsby, Dave Graham, Bud Reeser, Frank Evans, Jim Hill, and Dorsey Hill. This year the team lost more games than they won.

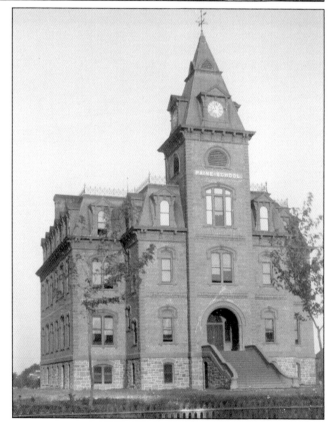

The first Paine School was built in 1888. It had four stories, with wooden sidewalks and a clock tower. This picture dates from sometime between then and 1902, when it was renamed Lincoln School. It was used only until 1927, when the building was torn down. A new Paine School was erected in 1928 in the same location and today is used as an alternative school for all ages.

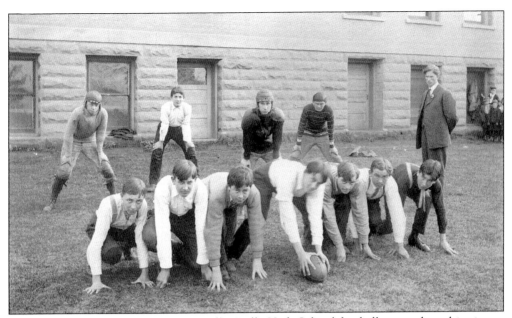

Professor Stafford was coach of the Walla Walla High School football team when this picture was taken in 1908. At this time the high school had moved from its temporary quarters at the Paine School to a new school on Park and Palouse Streets. E.J. Klemme was the principal and there were 12 teachers.

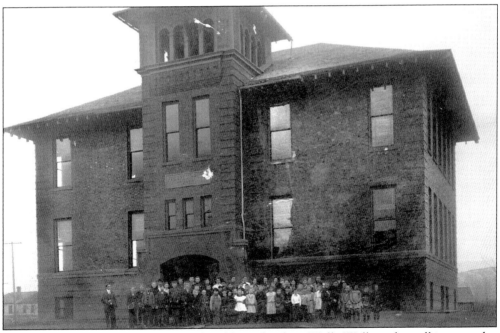

The Prospect Point School is one of the oldest schools in Walla Walla and is still in use today on Prospect Avenue. This structure was replaced in 1970 when a new building was erected on the same site as the original.

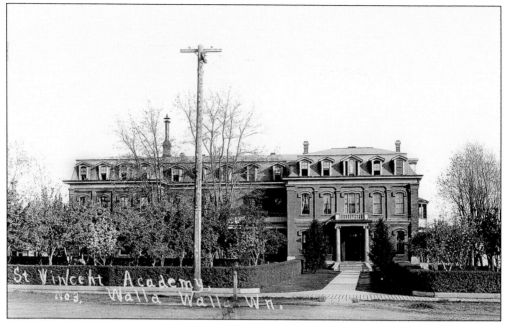

St. Vincent's Academy, a school for girls, opened on West Poplar Street on February 18, 1864, by the Sisters of Providence. It was named for St. Vincent de Paul, the patron saint of charity. The school was rebuilt in 1879–1880 and operated until 1932. In 1962 it became St. Patrick's convent. This picture dates from the 1910s.

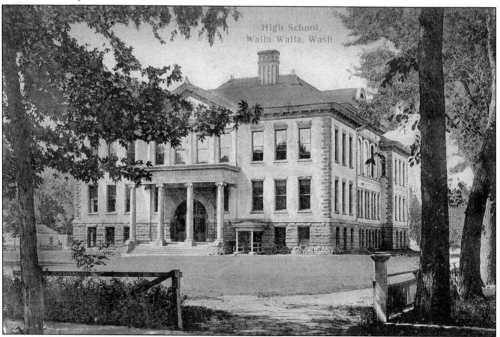

This is how the high school looked c. 1924 at its location at Park and Palouse Streets. W.A. Lacy was the principal during this time. The school had been rebuilt after a 1917 school bond passed, expanding the school to triple its original size. This facility was used until 1963, when a new facility was opened south of town. The school mascot is the Blue Devils.

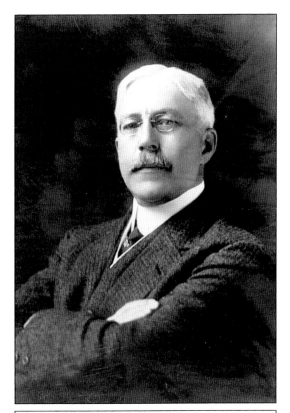

Pictured are Stephen B.L. Penrose and his wife, Mary. Penrose served as the third president of Whitman College from 1894 to 1934. Just 29 years old when he took over, he was the youngest college president in the United States. In 1924, he lost his eyesight, but amazingly he ran the college for another ten years. Penrose House, the admission office, and Penrose Library are named for him. Mary served as a member of the national board of directors of the YWCA and president of the local YWCA. She was active in the First Congregational Church and was a member of the Daughters of the American Revolution. The couple also established Penrose Point State Park in Puget Sound. The area served as a summer escape from the heat; the property eventually became part of the state park system.

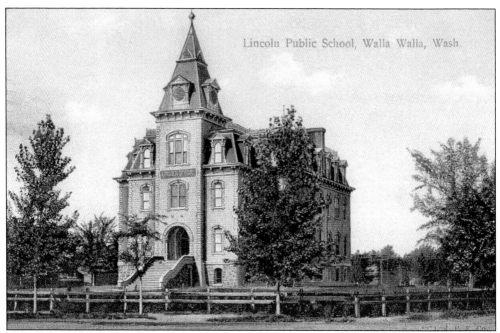

This picture of Lincoln Public School dates from approximately 1913. It had been formerly named Paine School. It was located off Walnut Street between Third and Fourth Avenues.

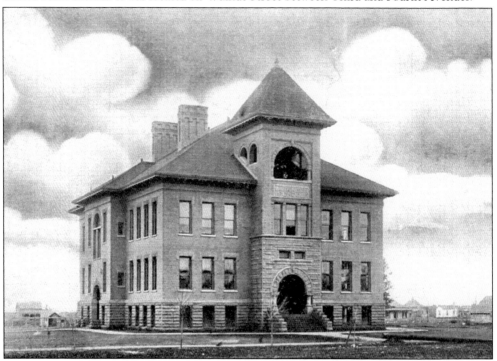

Washington School was built in 1904. The school was located on North Ninth Avenue between West Cherry and Pine Streets. It was used as a school until 1982. Today the building is no longer used for school but has been subdivided into apartments. Sadly, the old schoolyard has been completely neglected.

The first Whitman College gymnasium was a wooden structure built in 1891. That building was sold and the money was used to build the grandstand on Ankeny field. This newer building was completed in 1905. It had a "swimming tank," separate dressing rooms for men and women, and a main exercise hall. The Sherwood Athletic Center replaced the gymnasium in 1968. The Olin Hall of Arts and Humanities was built on the site of the old gymnasium in 1972.

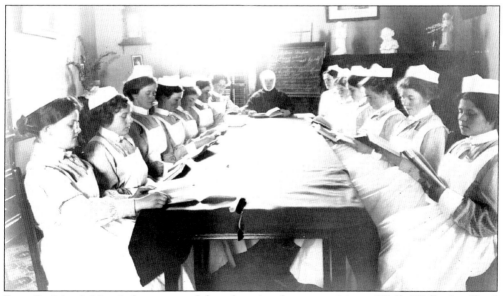

Even St. Mary's Hospital was part of the educational opportunities at Walla Walla. It offered a student nursing program to young women. In this picture, 13 student nurses study with their teacher, a nun at the hospital. The picture dates from about 1914.

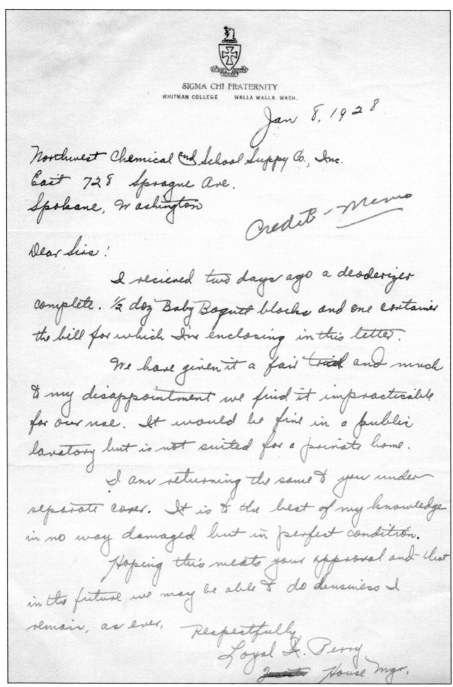

SIGMA CHI FRATERNITY

WHITMAN COLLEGE WALLA WALLA WASH.

Jan 8, 1928

Northwest Chemical and School Supply Co., Inc.
East 728 Sprague Ave.
Spokane, Washington

Credit - memo

Dear Sir:

I recieved two days ago a deoderizer complete. ½ doz Baby Boquet blocks and one container the bill for which I'm enclosing in this letter.

We have given it a fair trial and much to my disappointment we find it impracticable for our use. It would be fine in a public lavatory but is not suited for a private home.

I am returning the same to you under separate cover. It is to the best of my knowledge in no way damaged but in perfect condition.

Hoping this meets your approval and that in the future we may be able to do business I remain, as ever, Respectfully,

Loyal F. Perry

House Mgr.

Like most colleges, Whitman College had sororities and fraternities. This letter is from the Sigma Chi fraternity, which was chartered in 1920. It occupied a boarding house at 1005 Isaacs Avenue in 1920. The letter is from the fraternity house mother to a Spokane supply company, returning some merchandise that was bought for use at the fraternity. She explains how the product is unsuitable for use at the fraternity. Sigma Chi built a new house in 1938, and that structure still stands today.

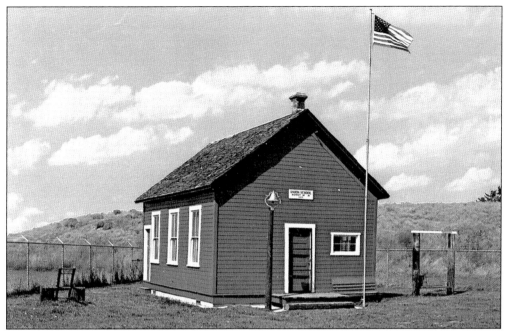

Union School was part of School District #26. It was located approximately 10 miles northeast of the city limits and was used from 1867 to 1930. This building was later moved to the grounds of the Fort Walla Walla Museum.

There are many unsung organizations that play a part in the high school experience. One such organization is this group of students that served on the 1942 senior play committee. On the front row, from left to right, are Helen Zahl, Adele Harris, Betty Jones, Lorraine Maughan, and Marian Reynolds. On the back row, from left to right, are Dorothy Nieman, Patricia Yeend, and Choessler.

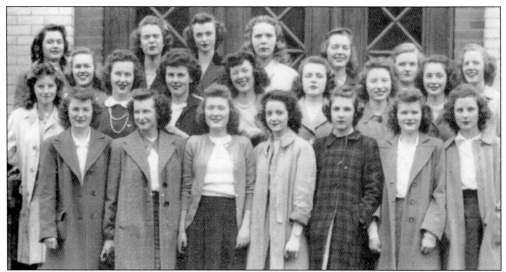

The unusually named Gimmel Teth club was responsible for selling season tickets for athletic events. The 1944 team is identified by last names only. From left to right, they are (front row) Elliot, Evander, Mahan, McEvoy, Angel, L. Mahan, and McGifford; (middle row) Cannon, Chapman, Nordstrom, Buck, Shuham, McLaughlin, and Lyman; (back row) Corkrum, Loney, Mathison, Humphrey, Rader, Harvey, Walton, and Croxdale.

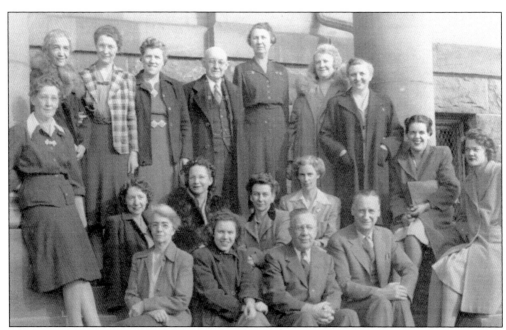

These teachers were among the high school staff in 1944. They are (front row) from left to right, Mary Yates, Helen Reser, Hal Tilley, and Harrison Clark; (middle row) Ivy Peterson, Mary Westacott, Allison, Marguerite Moseley, Helen McCormick, Laura Lee Robison, and Marian Bulow; (back row) Myrtle Falk, Dollie Corn, Dessie Larson, Clarence Steelsmith, Fay Hamm, Bess Kirk, and Mabel Graham.

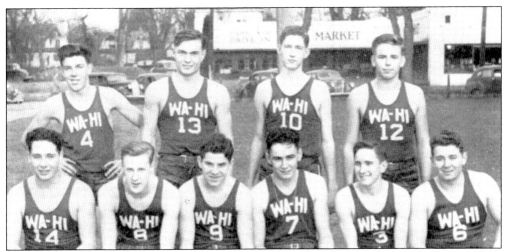

In 1945, Walla Walla High School had just ten players on the varsity basketball team. Even so, they had an excellent season with 23 wins and 4 losses, winning the district championship. They are (front row) from left to right, Duane Gilmore, Jerry Taylor, Don McMann, Harold Haupt, Stan Roseboro, and Bob Le Roux; (back row) Jay Childers, Bob Plucker, Jim Mitchell, and Don Fuller.

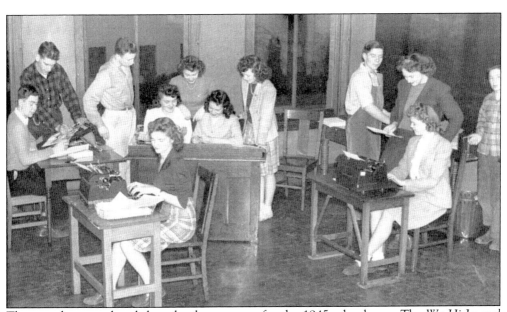

These students produced the school newspaper for the 1945 school year. The *Wa-Hi Journal* received an All-American rating. Standing, left to right, are Warren Baslee, Everett Skubinna, Marie Campbell, Janet Hamilton, James Renick, Phyllis Kidwell, and Pat Maher. Seated, from left to right, are Ted Bryant, Paloma Bacon, Pat Finnegan, Ethelmae Allen (editor), and Glenadine Wolfe.

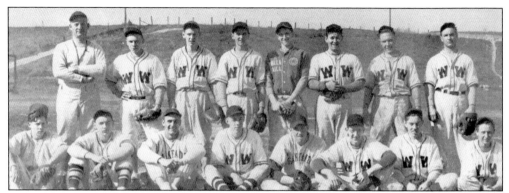

The 1945 high school varsity baseball team had high hopes for the year. From left to right (front row) are, Cornwell, Meinhart, George Fulgham, John Heath, John Fouts, Jim Mitchell, Ronald Duckworth, and Gene Frank; (back row) Coach Orville Hult, Don Klicker, Royce Lockhart, Dick Frank, Stan Roseboro, Bob Le Roux, Gene Pope, and Ed Fiedler. The team placed in the state tournament.

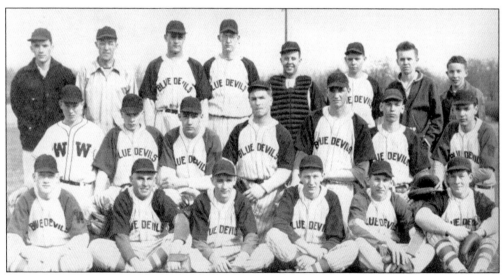

Many players from the previous year returned for the 1946 baseball season, including Ed Fiedler, Jim Mitchell, and Gene Frank. Seventy boys played baseball on three teams this year, including 20 on the varsity team. Though it was close, the Yakima team eliminated the Walla Walla boys from the state tournament in an inter-district playoff.

This is the main high school building as it appeared in 1946. That year some ground improvements were made by planting shrubs on the Palouse Street side. New walks replaced the old worn out paths. Tennis courts were in the process of being built. The Broadcasting Club and the Drama Club were organized this year. Dean Lobaugh was the principal during the 1940s.

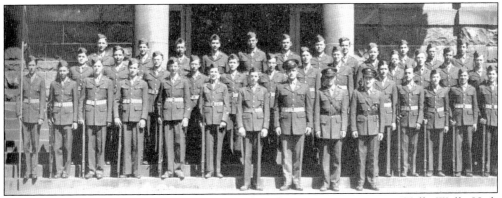

Reserve Officer Training Corps (ROTC) has long been an institution at Walla Walla High School. This is Company C from the 1946 class. The captain was Bob Rupp. Other officers included Melvin Hankla (1st lieutenant), Darrel Jones (2nd lieutenant), Mike Fahey (2nd lieutenant), and Norman Naucler (1st sergeant). The program began in the 1920s and is still part of the high school curriculum.

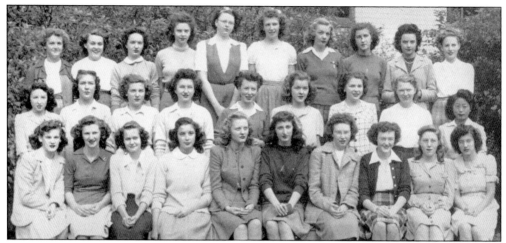

This is a typical homeroom class picture from 1946. The label states that it is home room #215. From left to right, they are (front row) McDaniel, Dirks, Mulhair, Lyman, Jamieson, Johnston, Townsend, Casey, Shevlin, and Klundt; (middle row) Buerstatte, Butherus, Newton, Frank, Lowman, Cochran, Lindstrom, Kralman, and Adachi; (back row) Sarver, Reihl, Benefiel, Tomlinson, Marshall, Clark, Danielson, Miller, Grassi, and Rimpler. For some reason, no first names are listed for the underclassmen.

These students produced the 1946 Royal Blue yearbook. Due to aggressive marketing, 750 annuals were sold this year, the most ever sold. This year the students were able to finish the yearbook a bit earlier than their deadline of May 1, so distribution to students was also early. Rosalyn Anderson and Mark Cook were co-editors.

The Future Farms of America (FFA) club is a part of many high schools and Walla Walla is no different. In 1946, the organization had 55 boys. These boys took many honors at the spring Junior Livestock Show. Norman Miller and Earl Smith were awarded State Farmer status at the state FFA Convention. The boys created the Grass Co-Op, the first high school in the state to create such a group.

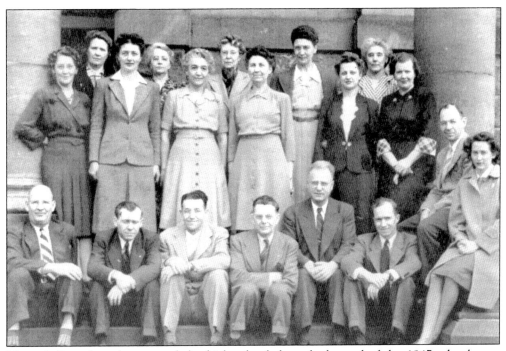

Many dedicated teachers served the high school through the end of the 1947 school year. From left to right, they are (front row) B.E. Austin, Donald Anderson, G.W. Ledbetter, Paul Reed, B.A. Tack, Eugene Meiners, W.B. Wheeler, and Bessy J. Fiset; (middle row) Ivy Peterson, Grace Houghton, Myrtle Falk, Fay Hamm, Florence McGovern, and Meta Pfeiffer; (back row) Ruth MacDonald, Mary Yates, Lucille McIntyre, Dollie Corn, and Juliana Draper.

THE BLUE BOOK
WALLA WALLA HIGH SCHOOL
WALLA WALLA, WASHINGTON

Published by
Associated Students
SEPTEMBER 1959

At Walla Walla High School, the Associated Student Body published these booklets to assist students with the high school experience. This little book from 1959 contains 74 pages of helpful information, particularly for new and transferred students. There is a campus map and a classroom map. There is information on the history of the school, a description of the various clubs, and a list of the school cheers and fight songs. The booklet also includes an extensive description of the bylaws and officers of the Associated Student Body for those so inclined to participate in student government.

Adult education began as early as 1947. By 1959, the program needed more space. Fortunately, the high school vacated its old premises in 1963, and by 1967, Walla Walla Community College was established at the old high school. Dr. Eldon Dietrich was the first president. Pictured is the main classroom and office building, but there was also a gym and fine arts building.

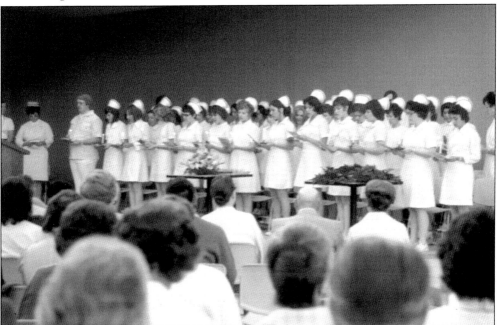

The nursing program was established in 1971 and is one of the most popular programs at the college. This graduating class was pinned at the new college campus at Tausick Way in 1975. The community college had quickly outgrown its space at the old high school campus. Funds were appropriated and the new campus was open for business in the summer of 1974.

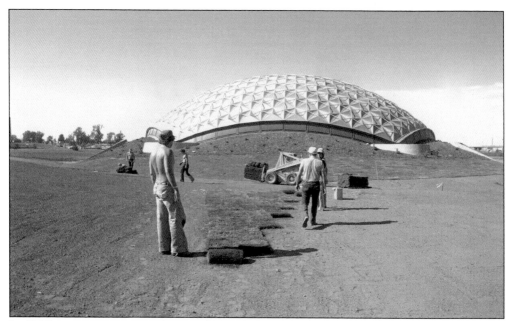

In 1977 construction is nearly complete on what would be known as the Dietrich Activity Center, named for the school's first president. Eldon J. Dietrich had served as teacher, athletic director, and principal in other Washington schools before coming to Walla Walla. The dome contains 158,000 bolts holding 1,000 gold-anodized aluminum panels that weigh 45 tons. Inside are 4,000 seats for concerts and athletic events.

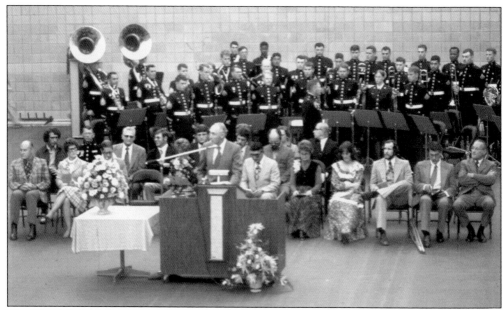

The Dietrich Activity Center was dedicated on October 13, 1977. I.C. Smith from the board of trustees, addressed the assembly. The U.S. Marine Corps band played for the celebration. Walla Walla Symphony director R. Lee Friese was on hand and declared the Dome would be perfect for that year's production of *Messiah*. The dedication completed 14 months of construction and an expenditure of $1.7 million.

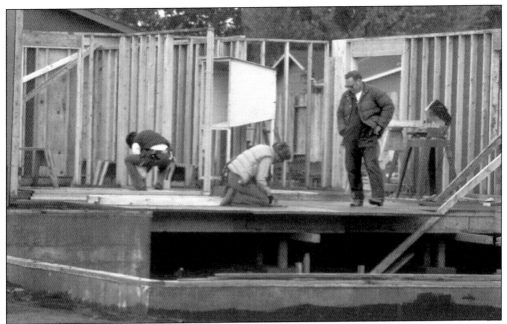

Each year since 1979, the carpentry class at the Walla Walla Community College has built a house using skills they learn in school. The construction projects are funded from a charitable foundation managed by the college. Money from sale of the buildings goes back into the foundation to finance the next project. In this picture, a student puts finishing touches on their first project.

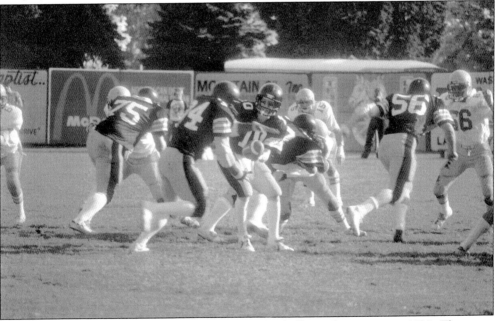

The Walla Walla Community College Warriors football squad practices in 1981. That year, they went 7-2 in the regular season. They beat Spokane Falls Community College in the playoffs by a score of 10-0, after a 73-yard interception for a touchdown. Their coach was Gary Knecht. The team also won state championships in 1979 and 1982.

Walla Walla College in College Place, just on the outskirts of Walla Walla, provides another opportunity for a college education. The school first opened on December 7, 1892, with 150 students. The school is owned and operated by the Seventh-Day Adventist Church. This is the administration building, rebuilt in 1919 after a fire destroyed the roof and the rest of the building suffered from water damage.

This is the main administrative building on the Walla Walla Community College campus and contains the administrative offices for the college. There are some classrooms and faculty offices as well. Student lunchroom, library, student lounge, and computer center are also housed here. The registration office and campus book store occupy part of the first floor.

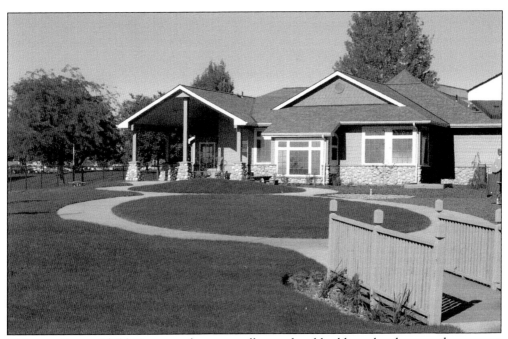

This new Parent Child Center replaces a smaller outdated building elsewhere on the campus. The new building was another project of the community college's carpentry class, who built the facility from the ground up.

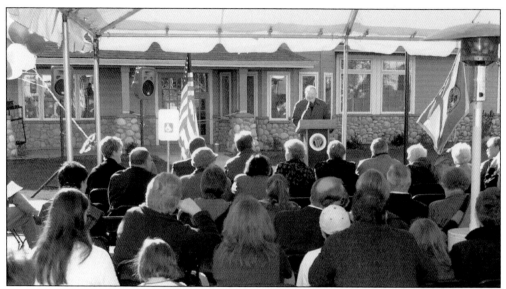

Current president Steven L. VanAusdle presides over the dedication of the Parent Child Center. VanAusdle has been intimately involved in education since he begun his career as a part-time instructor in 1969.

The original Hall of Science was erected at Whitman College in 1963. In 1981, a 17,000-square-foot wing was added. In 2003, it received another face lift. Several enhancements were made including the addition of a building-wide wireless network for Internet access, a scanning electron microscope, planetarium, biochemistry laboratory, and greenhouse. Several large telescopes were also added.

Seven

MODERN TIMES

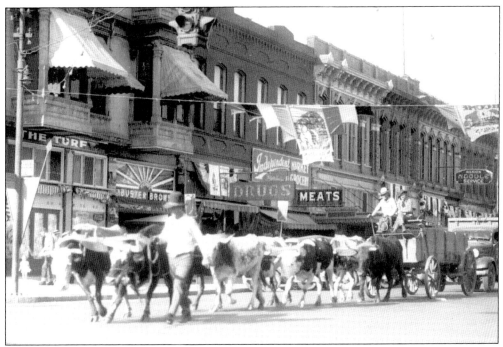

This view of Main Street was likely taken in the 1940s. Taking products to market, the old-fashioned way, by wagon, looks out of place among modern trucks of the times. On the north side of the street include The Turf Saloon, Independent Market, Buster Brown, and Nankin Noodle Service.

THE FATHER OF WATERS

Pantorium DIE WORKS

Phone 393 ═══ Call Us

Send it to a Master — NATIONAL ASSOCIATION — DYER AND CLEANER — DYERS AND CLEANERS

WALLA WALLA, WASH.

B30172 © LOUIS F. DOW CO. ST. PAUL · WINNIPEG

The Pantarium Die Works has served the cleaning needs of Walla Walla for several decades. The company made tailored suits, repaired carpets and rugs, and washed and pressed clothing. At the time of this advertisement from the 1940s, the business was located on Second Avenue. It was owned by John Stoller and Robert Wentsch. The company has occupied several buildings since the early days.

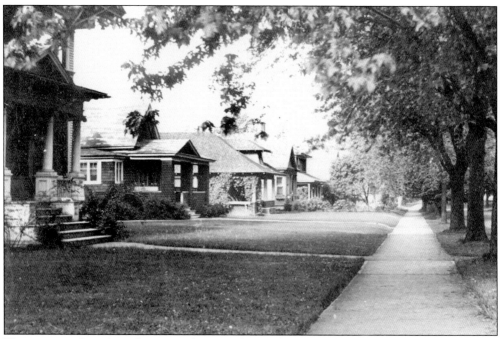

This is a typical residential street in the central part of town, in the 1940s. Grass lines the street, as well as either side of the sidewalks. Pictured is University Street, near the college campus. Though the homes are not overly large, they are substantial enough for a family of four to live comfortably. Many of these old homes still exist in the university district.

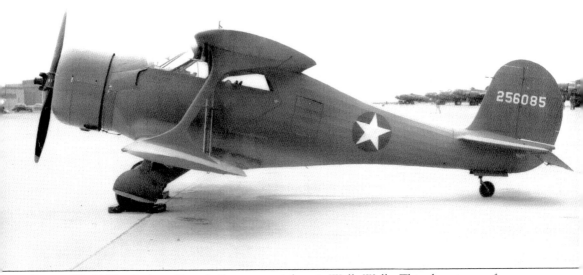

During World War II, the military built an army air base in Walla Walla. This plane is one of many stationed at the air base, located where today's modern airport is situated. Construction began on February 9, 1942. Lt. Col. Earl T. Vance was the base commander. The Second Air Force used the base until December 1943. It was reopened on May 15, 1944, and used by the Fourth Air Force. It closed permanently on August 31, 1947, and the property was turned over to the city.

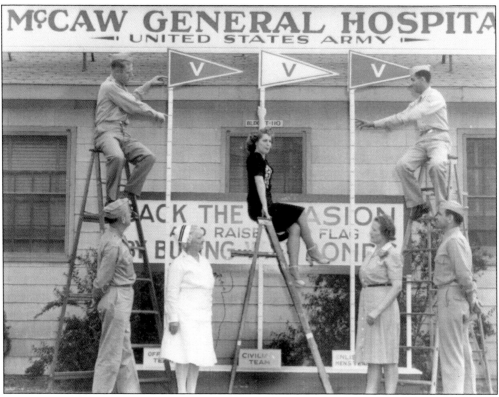

The U.S. Army built McCaw General Hospital near the veterans' hospital. The hospital opened February 20, 1943. During July 1944, the hospital participated in a war bond drive. Officers, enlisted men, and civilians competed with each other. When the hospital closed on February 15, 1946, some of the buildings were moved to Rose Street, where they were used for student housing for Whitman College.

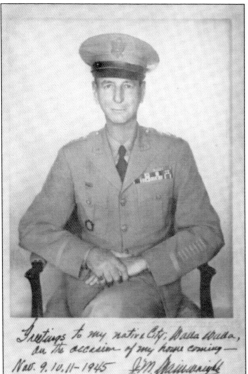

Gen. Jonathan Wainwright became famous during World War II as the commanding officer in the Philippine department. But for Walla Wallans, he is one of their most famous native sons, having been born in Walla Walla at the old fort in 1883. This picture was taken during a return visit to Walla Walla in November of 1945, shortly after his retirement from military duty.

WALLA WALLA CANNING COMPANY

TELEPHONE-509

WALLA WALLA, WASHINGTON

March 17, 1950

TO ALL STOCKHOLDERS:

 At a meeting of the Board of Trustees of the Walla Walla Canning Company held on February 29, 1950, it was voted to pay a dividend of $6.00 per share on the Common and Preferred stock of the Company on March 20th to stockholders of record as of March 15th.

 Enclosed you will find check to cover such dividend.

 If you have changed your address please advise us of your new address.

Yours very truly,

WALLA WALLA CANNING COMPANY

F. L. Jones

By F. L. Jones
Secretary-Treasurer

FLJ:f
Enclosure

The Walla Walla Canning company broke ground on February 6, 1933. P.J. Burke was the manager. Initially the canning company packed asparagus, tomatoes, tomato juice, prunes, spinach, strawberries, raspberries, beans, cherries, and green peas. By 1933, the Walla Walla Canning Co. packed 88,781 cases of peas. By 1936, six area canneries processed 1.9 million cases of peas. By 1943, canneries packed 6.5 million cases. Peas were a desirable crop as it fixed nitrogen into the soil. The company was still in operation in 1950, when this letter was written, awarding dividends to shareholders.

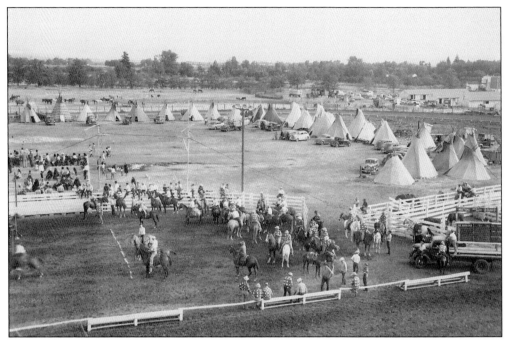

During the years of World War II, the fair was not held in order to preserve precious resources, though a parade was often held. By the late 1940s, the fair started up again in earnest. These teepees are set up in the infield of the race track on the fairgrounds. The teepees look out of place amidst the modern vehicles.

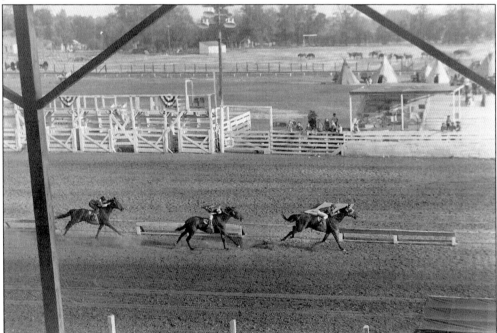

Several races of varying lengths were held this year, probably 1949. Horse racing is the oldest Walla Walla Fair and Frontier Days event and has been part of the fair since 1862. Races typically feature quarter horses.

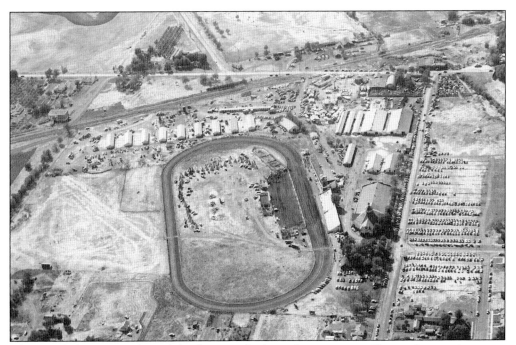

This aerial photo was taken of the fairgrounds about the same time. Tietan Avenue is seen at the top of the arena. It is obvious from the number of cars in the parking lots and along the streets that it was another well-attended fair.

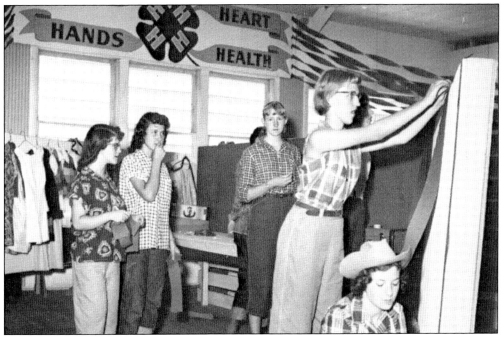

These girls assemble an exhibit for the 4-H club. The 4-H club organized nationally in the early part of the 20th century and locally in 1913. Walla Walla children have participated in its programs ever since. 4-H, which stands for "head, heart, hands, health," has long advocated the development of civic responsibility in youth.

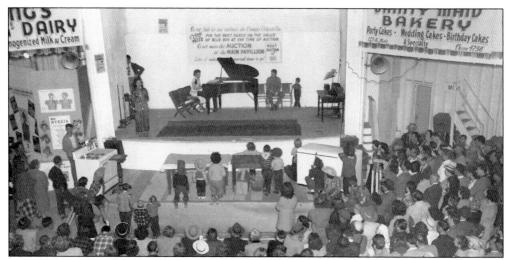

The pavilion at the fairgrounds is used for various types of indoor entertainment. In this picture from 1949 or 1950, large crowds gather to listen to a pianist. During the war years, this pavilion was used to hold between 600 and 800 German prisoners of war.

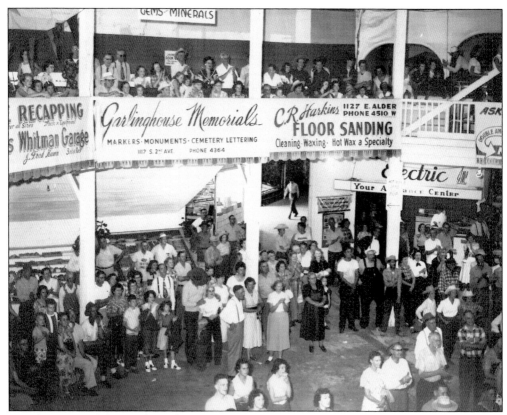

Another view of the pavilion shows the large crowds that gathered, even filling the second floor. Local businesses advertising their services contributed generously to organizing and conducting the fair.

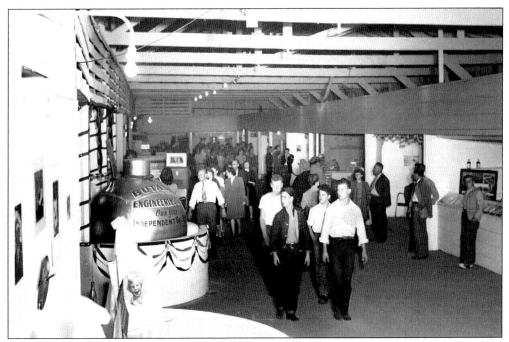

The pavilion has a central square under the steeple, with several wings extending out from the middle. These wings are used to display various vendor exhibits. Butane Engineering Company, Inc., the exhibitor shown at left, is a vendor of gas tanks and hot water heaters.

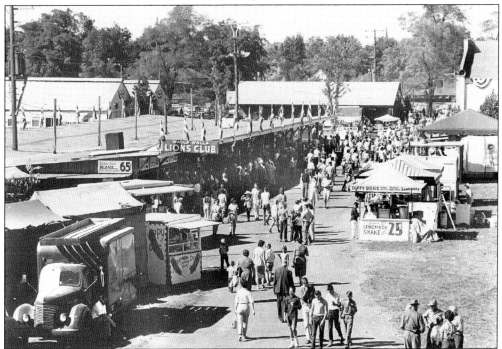

This photo of the midway of the county fairgrounds was taken in 1962. The midway with its food booths and carnival games have been a part of for decades. This year's fair is well-attended since, as usual, the weather in late August and early September is very comfortable.

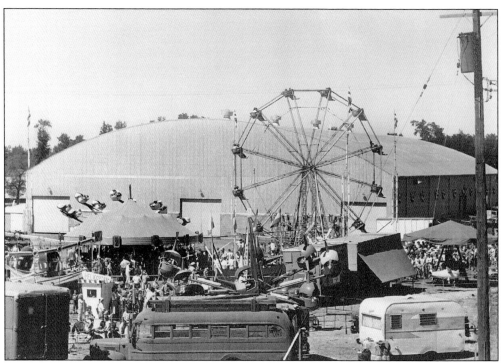

The Ferris wheel, Octopus, and other rides are fair favorites. Long crowds stand in line to take their turn at these rides at the 1962 fair.

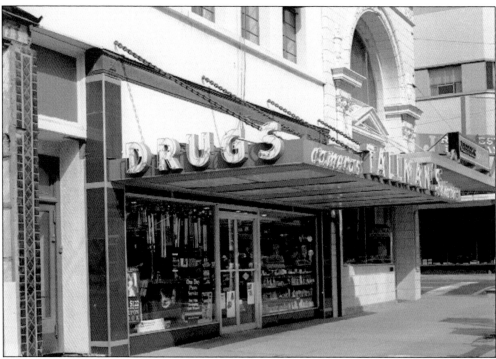

Tallman Drug and Camera has been a part of Walla Walla since at least 1902. Tallman's sits at the corner of Main Street and Second Avenue in the Quinn Building. This picture dates from the 1960s.

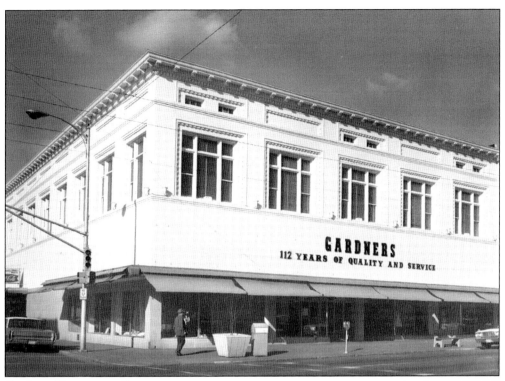

Gardners Department Store, located at Main Street and Third Avenue, was a mainstay in Walla Walla for over 100 years, approximately 70 of them at this location. It was first opened in 1860 by the Schwabacher brothers. In 1909, H.A. Gardner and Associates bought the business and changed its name. It celebrated its 100th anniversary in 1960 with a huge open house. This picture was taken in January 1964. Gardners operated until 1980.

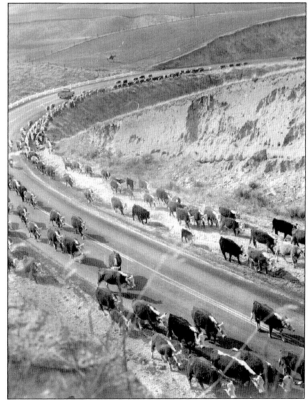

Raising livestock was never a large part of the county economy. But there were still some cattle ranchers by the time this picture was taken in the mid-1960s. It seems odd to see cattle walking along a paved highway with guard rails.

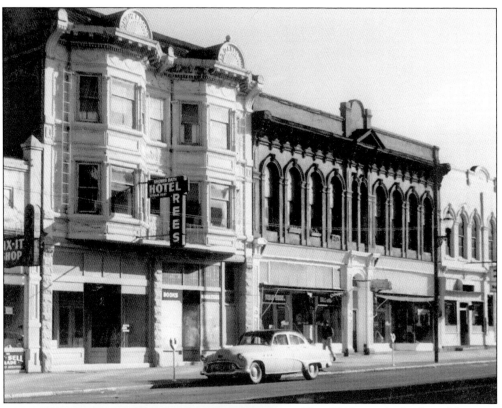

This 1968 view looks down Main Street between Fourth and Fifth Avenues. Several businesses line the block, including the Fix It Shop, Rees Hotel, a book store, furniture store, and Mexico Lindo, a restaurant.

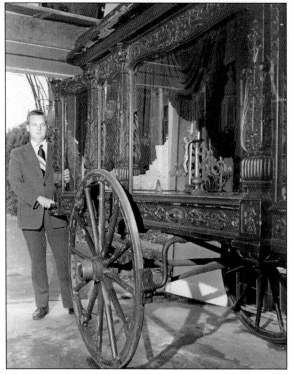

This fancy hearse was used by the Bill Watson Colonial Funeral Home in 1972. The hearse was 112 years old and had previously been used in Pennsylvania. It had rubber-lined tires and beveled glass panels. It is now on display at the Colonial-Dewitt Funeral Home at 19 East Birch.

COL Wm. Whipple
Oct. 1948 - Jul. 1950

COL W. H. Mills
Aug. 1950 - Mar. 1953

COL F. S. Tandy
Apr. 1953 - Jul. 1954

COL Alexander H. Miller
Aug. 1954 - Aug. 1955

COL Myron E. Page Jr.
Aug. 1955 - Aug. 1958

COL Paul H. Symbol
Aug. 1958 - Mar. 1961

COL James H. Beddow
Aug. 1961 - Jul. 1964

COL Frank D. McElwee
Aug. 1964 - Jul. 1967

COL Robert J. Giesen
Aug. 1967 - Aug. 1970

COL Richard M. Connell
Sept. 1970 - Jun. 1973

PRESENT DISTRICT ENGINEER
COL Robert B. Williams
May 1982 -

COL Nelson P. Conover
Jul. 1973 - May 1976

COL Christopher J. Allaire
Jun. 1976 - Aug. 1979

COL Henry J. Thayer
Aug. 1979 - May 1982

The Walla Walla District has been commanded by a number of U.S. Army colonels and lieutenant colonels. Col. William Whipple held the reins of the district at its inception. There have been eight other commanders since the last man pictured, Col. Robert B. Williams, who ended his term in June 1985. Williams was followed by James B. Royce, the last full colonel who served. Lieutenant colonels who have served as district engineers after Royce, were James A. Walter, Robert D. Volz, James S. Weller, Donald R. Curtis Jr., William E. Bulen Jr., and Richard B. Wagenaar. The current commander is Lt. Col. Edward J. Kertiz Jr.

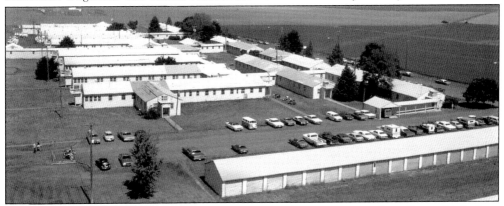

The Walla Walla District of the U.S. Army Corps of Engineers was formally established on November 1, 1948. From that day until 1995, the Walla Walla District occupied these, and other buildings, of the abandoned army air base. The formation of the Walla Walla District occurred at the time of their first dam-building project, which was McNary Dam on the Columbia River.

The Walla Walla Balloon Stampede has been a popular valley celebration since 1974. Local balloonists Bill Lloyd and Nat Vale started the event with just a few pilots. Hot air balloons used to be used for weather studies but today are used almost exclusively for recreation and sports. During this celebration in 1987, about 40 balloons were launched.

The balloons will only launch in calm winds, generally 10 m.p.h. or less. To ensure a successful launch, flights are scheduled two to three hours after sunrise and two hours before sunset, when winds are calmest. The Balloon Stampede of 1987 was blessed with calm winds, and dozens of balloons were able to launch from the Walla Walla High School campus at Fern Avenue and Abbott Road.

Each festival has other events, besides the balloon launch. There are games for the kids, vendor booths, plenty of good food, and souvenirs. In 1998, approximately 100 booths entertained and educated visitors at the Walla Walla County Fairgrounds. About 30 sold food, with the rest containing arts and crafts and commercial vendors.

Tony the Tiger® is a frequent visitor to the Balloon Stampede, both on the ground and in the air. Here he is at the 1998 Balloon Stampede greeting fair goers. Other entertainment included Adventureland with rides and an inflatable play area for the kids. The Royal Express also debuted, featuring a trackless train.

The Mill Creek Dam was erected in 1942. The dam is an earthfill structure with a heavy gravel face. It is 800 feet wide at the base, 20 feet wide at the top, 125 feet high, and 3,200 feet long. The dam serves mainly as a flood control structure. The reservoir created behind the dam captured flood water diversions in 1971 and 1975. The road to the recreation area was paved in 1972.

In March 1996, the U.S. Army Corps of Engineers moved from their old headquarters at the airport, to this new building on Third Avenue. It took ten years of planning, site selection, and building to make the move. A Decommissioning Day Ceremony was held at the old facility on February 24, 1995. The event was well attended, with several longtime retired district employees giving speeches.

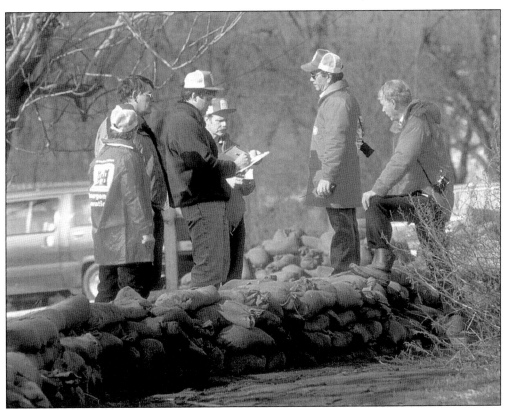

In February 1996, extensive flooding hit the Columbia Basin. Early spring melting caused overflow of the Yakima, Walla Walla, and Touchet Rivers, and Mill and Patit Creeks. Benton City, West Richland, Touchet, Walla Walla, Waitsburg, and Dayton experienced flooding in the streets that caused severe damage. The Walla Walla district of the U.S. Army Corps of Engineers was involved in the flood control effort, including the erecting of sandbag dikes.

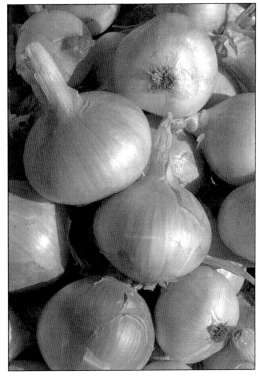

Today, the Walla Walla Sweet Onion is known throughout the state and the country. To be called a Walla Walla Sweet Onion, it can only be grown within very specific geographical boundaries. Its sweet flavor comes from a low sulfur content and high water content. These yellow onions tend to be large and globular and very uniform in shape and size.

113

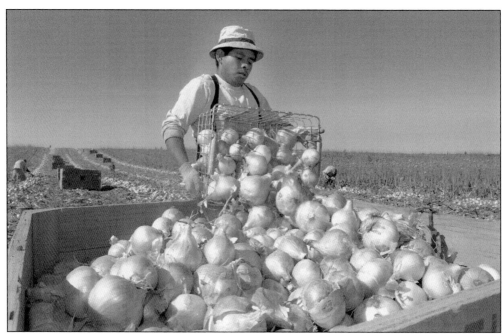

There are currently approximately 38 growers cultivating about 1,200 acres of onions. Planting is done in early fall, with harvest beginning the first week of June. Spring seeding also occurs in early March for harvest in late July or early August. This man brings onions from the field to a larger bin.

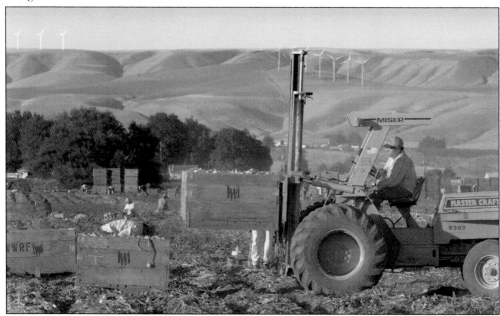

Just like most crops, Walla Walla Sweet Onions are susceptible to a variety of pests. They can also be hurt by an early freeze shortly after sowing or excessive heat in the summer. This field may look lush, but the arid desert encroaches all around. In the background, you can also see several wind turbines, part of one of the largest wind farms in the Northwest, with over 250 windmills.

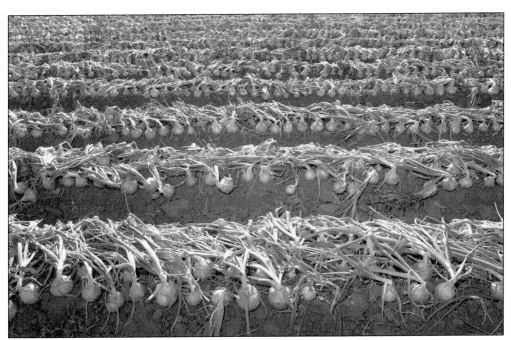

Yield per acre is very high. The average acre yields approximately 650 50-pound units, equal to about 32,500 pounds of onions per acre! That number is easy to believe, looking at these rows of onions. These onions have been "undercut," and will lay several hours to harvest. They will then be pulled by hand and the roots and tops trimmed off before being placed in bins.

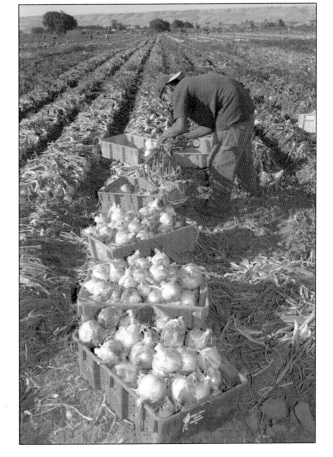

Like most farmers, onion farmers also rotate their crops to keep them fertile. Most maintain a two or three year rotation. Some of these fields stretch for yards, as far as the eye can see, such as this one, in the process of being harvested.

As the most famous crop in the area, it is only natural that there would be an annual festival to celebrate the Walla Walla Sweet Onion. The festival takes place in July, to coincide with harvest time. Like a county fair, growers exhibit their finest onions in a contest.

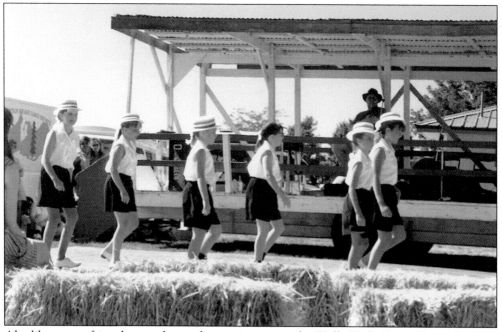

Also like county fairs, there is plenty of entertainment at the Walla Walla Sweet Onion Festival. At this celebration in 1994, the Blue Mountain Square Dance Council shares some dances with the crowd. The festival took place on the Fort Walla Walla Museum grounds.

Potatoes were first planted at Fort Nez Perce in 1825 and at the Whitman Mission about 1853. They are thought to be the area's first crop. They have been grown by most truck gardeners and are harvested in mid-June. Here is a healthy potato field about 15 miles west of Walla Walla near the small community of Touchet.

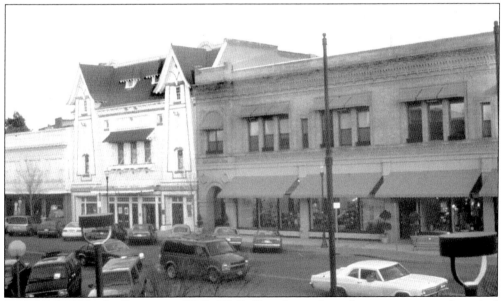

In the mid-1980s, the Downtown Walla Walla Foundation formed to restore various historical buildings. Restoration of the Liberty Theater began in 1991, and the facade was restored to its original 1926 appearance. The Die Brucke Building next door dates from 1903, and was renovated in 1994. This space is currently occupied by Bon Macy's juniors and young men's departments.

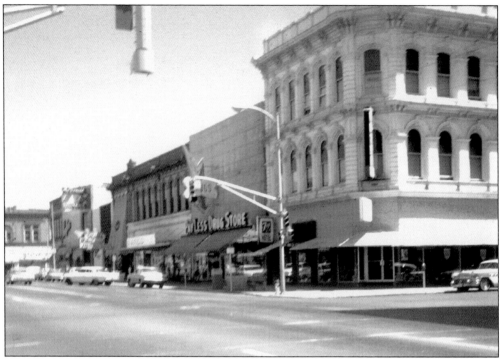

This view of Main Street was taken about 1980, before renovation began, but after it was recognized that the downtown had gotten shabby. The foundation raised $350,000 initially, plus conducted numerous fund-raising programs to finance the restoration. Each property owner arranged their own restorations using different contractors.

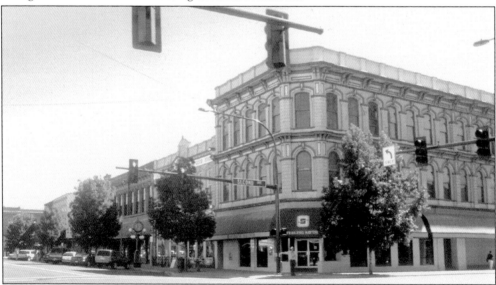

Here is the same block after renovation was completed in 1993. The exterior was repainted and refronted. Much of the interiors had to be brought up to code. The Sterling Savings Bank occupies the corner space today. Next to the bank is the Reynolds-Day building, now occupied by Falkenberg's Jewelers, Grapefields wine bar, and others. The second story once served as a meeting place for the first State Constitutional Convention in 1878.

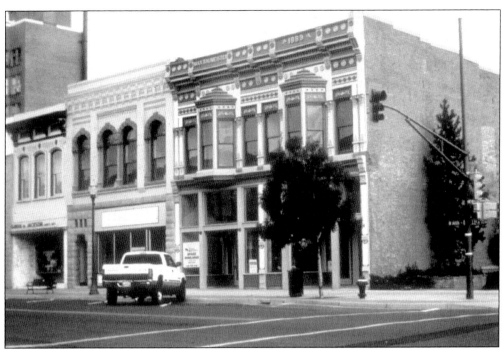

Restoration of the 1889 Baumeister Building on Main Street was complete in 1998. A metal facade was affixed to the building as part of the restoration. The building is occupied by various businesses including an attorney's office, a brokerage, and a mortgage company. Collectively the renovations have earned numerous awards for restoration work, architectural excellence, and preservation.

The Marcus Whitman Hotel has been standing since 1928. Since then, it has been the tallest building in Walla Walla, serving as a hotel and conference center. The hotel received its own facelift, inside and out, which cost about $25 million. Renovation was completed in 2001. Besides hotel and conference space, the Marcus Whitman has a fine restaurant, office space, and residential units in the top three floors.

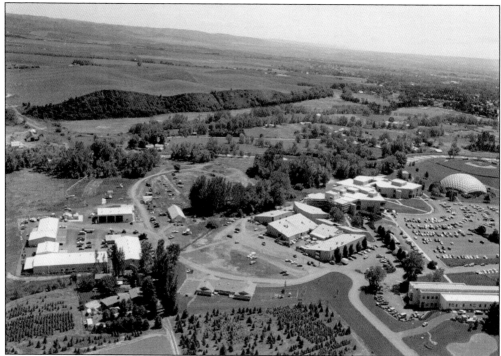

This aerial photo of the Walla Walla Community College was taken in 1997. The school grounds contain 21 major buildings. Several buildings were recycled from the World's Fair that took place in Spokane in 1974, including the China Pavilion, the Joy of Living Building, and the Energy Building. These buildings provide space for welding, machine shop, civil engineering, automotive, and cosmetology programs. The campus occupies nearly 100 acres.

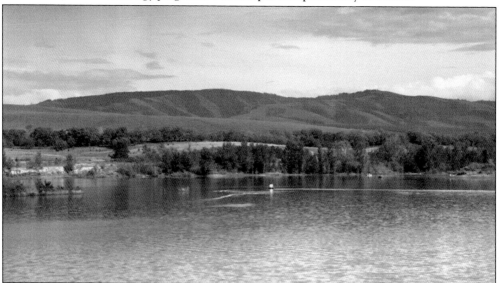

Virgil B. Bennington Lake is a favorite fishing and picnic area on the outskirts of town. The lake has a capacity of 8,300 acre-feet. Once called Mill Creek Pond, it was renamed for Virgil B. Bennington, former president of the Walla Walla Chamber of Commerce, in 1992. Bennington was also the first chairman of the state game commission when it was formed in 1933.

St. Patrick's Catholic Church is one of the oldest churches in Walla Walla. This building has stood since 1881 under the leadership of Father Thomas Duffy. But the church was first organized in 1847, with the first church building constructed in 1859. The church still stands today on Alder Street.

Winsoms of Walla Walla is one of the city's newest businesses. Winsoms distributes fine food products featuring the Walla Walla Sweet Onion. The business occupies this building on Melrose Street, formerly owned by Gene's Fine Foods. The building has been expanded and rebuilt several times since the 1960s. Manager Kevin Greenwald launched the distribution in August 2002 and opened a store on December 3, 2002.

In just one year of operation, Winsoms has delivered products to 38 states and several countries. One if its biggest customers is located in Tokyo, where American-made products are sold to tourists. This display shows many of Winsoms' products including "Good and Evil Hot Sauce," and other products that use Walla Walla Sweet Onions as an ingredient. This writer enjoyed the Sweet Onion Mesquite Steak Sauce.

This fair program, designed by Elaine Hinshaw, was printed to commemorate the 2003 Walla Walla Fair and Frontier Days. The program is second in a series of five commemorative programs that will be published, ending in 2006. That year celebrates the 100th anniversary of the pavilion, built on the fairgrounds in 1906. The pavilion, known as "The Grand Old Lady of the Fair," will be featured on the cover of each program. The history of the pavilion and other buildings and events of the fair will be covered inside, along with descriptions and a schedule of current events.

Key Technology started in 1948 as a small business in Oregon, founded by Claude and Lloyd Key. Its original product line was focused around machinery for the region's budding pea industry. Since then it has produced many innovations related to the agricultural industry, such as a machine that detects defects in french fries. In 1990, the headquarters of Key Technology was moved to this new facility in Walla Walla.

Walla Walla is home to many large trees, 59 of which are considered champion trees in the state, including the silver maple, black walnut, and scarlet oak. Some of these trees are located in Pioneer Park. This unusual tree has one of its main branches growing horizontal along the ground. This and the other sycamores around it were planted at the same time the bandstand was originally built in 1909.

Grapes and wines have been produced in Walla Walla since the 1900s. However, it wasn't until 1977 that the first modern winery opened. In 1984, the area become federally recognized as a unique American Viticultural Area, with four wineries and 60 acres of vineyards. Grapes now cover over 1,000 acres. The climate, soil, and long growing season result in flavorful grapes that are used in a variety of wines.

The Center for Enology and Viticulture was built on the Walla Walla Community College grounds. The center opened in September 2003, though the wine education program began in January 2000. Students can earn an associate degree in applied science in enology and viticulture. The first six graduates are all employed in the Washington state wine industry.

The Center for Enology and Viticulture is the first two-year college in the country that includes a teaching commercial winery. The center teaches all aspects of the wine business, from the planting of the vine, to harvesting the crop, to creating the wine. These stainless steel containers are used to forment the wine.

Pepper Bridge Winery, founded by Norm McKibben, is located on JB George Road. The winery specializes in Cabernet Sauvignon and Merlot with grapes from the Walla Walla Appellation. McKibben opened the facility in 2000 after several years of studying growing and harvesting techniques. Pepper Bridge crushes grapes from its own 180-acre vineyard as well as the 200-acre Seven Hills Vineyard.

Denise and Bret Eisenhower are the owners of Isenhower Cellars. Their wines have the colorful names of Red Paintbrush, Wild Alfalfa, Bachelor's Button, and Dragonfly. They have been harvesting grapes and making wine since 1999, with the generous cooperation of local wineries. In 2002, they erected their own facility on Pranger Road, where they make Cabernet Sauvignon, Merlot, and Syrah, among others.

Tamarack Cellars is one of several wineries that have opened in the old army air base buildings. Tamarack Cellars, owned by Ron and Jamie Coleman, is located in a restored fire station. They make Cabernet Sauvignon, Merlot, Chardonnay, and Firehouse Red from grapes in the Walla Walla Valley, as well as grapes from the Yakima, Red Mountain, and Columbia appellations. Their first wine was produced in 1998.

The Three Rivers Winery is another new winery, located just outside of Walla Walla on Highway 12. The business broke ground in August of 1999. It occupies a 16-acre site, which includes an 18,000-square-foot winery. Owned and operated by Walla Walla Wines, LLC, the winery is known for its Syrah, Merlot, and Cabernet Sauvignon.

The Canoe Ridge Winery is located on Cherry Street. Its vineyards are actually located near Patterson in southern Benton County, on the other side of the Columbia River. The winery is situated in a historic railroad engine house erected in 1905. Canoe Ridge is known for its Merlot and participates in the annual holiday barrel tasting festival.